C000080905

NORTHFIELD MEMORIES

JEAN & JOHN SMITH

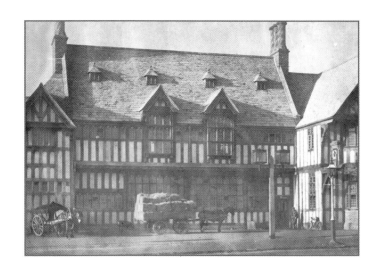

SUTTON PUBLISHING

Sutton Publishing Limited
Phoenix Mill · Thrupp · Stroud
Gloucestershire · GL5 2BU

First published 2003

Title page photograph: The Black Horse Hotel, *c.* 1920. In the 1870s a small, stone-built hostelry, with an estimated value of approximately £250, and run by a much-respected man named George Page, had, by the 1920s, been replaced by this half-timbered building. (*B. Denning*)

British Library Cataloguing in Publication Data
A catalogue record for this book is available from the British Library.

ISBN 0-7509-3041-1

Typeset in 10.5/13.5 Photina.
Typesetting and origination by
Sutton Publishing Limited.
Printed and bound in England by
J.H. Haynes & Co. Ltd, Sparkford.

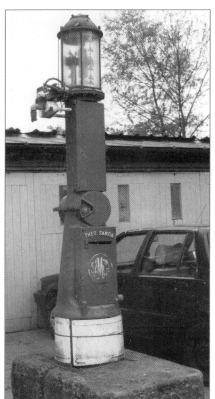

A 1932 Advertisement for Burtt's Garage. (*M. Broomfield*)

May 2002: An original petrol pump at the garage in Hole Lane where, in 1929, the brothers W.S. and E.C. Burtt first ran the petrol station. Sir Adrian Cadbury recalls Mr Burtt having to pump up the petrol from the underground tank until the glass dome on top of the pump was full, when the petrol then had to run down the hose into the car. As the process had to be repeated many times it took a very long time to fill the tank! Today it is known as RCT Motors and has been run by Robert Tilley for approximately ten years. (*J. Smith*)

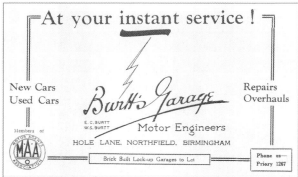

At your instant service !

New Cars
Used Cars

Burtt's Garage

E.C. BURTT
W.S. BURTT
Motor Engineers

Repairs
Overhauls

Members of
MAA
MOTOR AGENTS ASSOCIATION

HOLE LANE, NORTHFIELD, BIRMINGHAM

Brick Built Lock-up Garages to Let

Phone us—
Priory 1267

CONTENTS

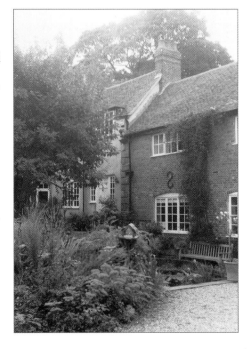

Quarry Lane derived its name from the sandstone quarry which was sited there in the sixteenth and seventeenth centuries. Quarry Cottage, which in 1988 Birmingham Museum and Art Gallery dated back to the late-seventeenth/early-eighteenth centuries, stands on the site of, and contains large sandstone blocks from, the quarry. Roof beams in the attic are thought to have been imported from elsewhere as they pre-date the cottage, and there are indications that the main part of the building, underneath which footings of other buildings are evident, had a third storey at some period in its history. The cottage, which is at least 100 years older than the farm, used to belong to Quarry Farm and has been occupied by farm workers and nail makers. A wall at the rear of the property is constructed entirely from nailers' pots and at the side of the property stands the original quarry wall. The present owners, Helen and Malcolm Simms, have lived in it for approximately nineteen years and are gradually restoring it by keeping as much of its original character as possible to fit in with modern-day living. (*J. Smith*)

ACKNOWLEDGEMENTS & BIBLIOGRAPHY

We would like to express our very grateful thanks to R. and D. Castledine, D. Chew, P. Edmunds, I. Gornall, R. Grey, N. Harrison, M. Hubbard, R. Mayne, T. Ryan, D. Smith, P. Sorrill, P. and I. Such, B. Whitehouse, O. Williams, Longbridge Social Club, West Park Avenue Social Committee, Birmingham Central Library's Archive and Local Studies sections, and Northfield Library, all of whom have given us considerable help. We would also like to express particular thanks to the *Bromsgrove Standard* for their continuing help and interest in our work, and the *Birmingham Evening Mail* for allowing us to use material and photographs from past articles in their papers, to Carl Chinn for his continued interest in our work, and to many more people of Northfield, and further afield, too numerous to mention individually, for providing photographs and information for our use.

Occasional Papers issued by Northfield Conservation Group
Alan Crawford and Robert Thorne – *Birmingham Pubs 1890–1939*

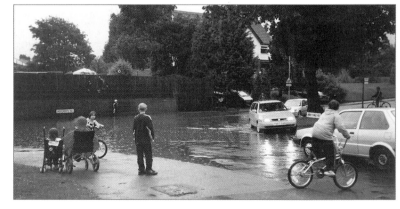

Flooding at the junction of Station Road with West Heath Road in 1999. After the severe flooding of recent years which devastated streets and houses in the Middlemore and Station Road's area of Northfield, local campaigns led to a £1.7 million flood defence system being provided by the council. This resulted in the rebuilding of two bridges along the River Rea at West Heath Road and Coleys Lane, where the previous bridges were unable to withstand the high volumes of water during a flash flood. Following the flooding of many properties four times between September 1998 and July 2000, torrential rain on 31 July 2002 threatened severe flooding throughout Birmingham once again. However, thanks to the implementation of the River Rea Improvement Scheme, local residents breathed a huge sigh of relief when the new defences succeeded in protecting their homes from further flooding. (*G. Harper*)

ABOUT THE AUTHORS

Jean Smith (née Whitehead) was born in Bournville, Birmingham, in 1940. Educated at Sparkhill Commercial School she worked as Secretary to the Sales Manager at Cadbury Brothers Ltd prior to marriage. From the age of seven she had enjoyed studying music and nurtured the wish to teach. After bringing up a family she studied at Birmingham School of Music and Birmingham University to gain teaching and performing qualifications in music. She then taught piano, theory of music and general musicianship in schools, privately and in Adult Education, in addition to performing, accompanying and being founder and Musical Director of Northfield Leisure Singers. Jean is currently involved in voluntary work for St Mary's Hospice.

John Smith was born in Hampshire in 1942. Educated at Churcher's College, Petersfield, he then joined Cadbury Brothers Ltd at Bournville in 1960 as a commercial trainee with the likelihood of eventually taking over the family newsagents and confectionery business in Winchester. He met Jean, married, settled in Northfield and remained in Birmingham. He retired from Cadbury Ltd in 1996 after thirty-five and a half years' service, mainly in the Wages, Personnel and Administrative Departments. Keen on music and amateur theatre, John is currently Honorary Secretary of Birmingham Conservatoire Association. He collects recorded music and gives talks with musical illustrations to local groups and societies. (*Birmingham Evening Mail*)

INTRODUCTION

The manor of Northfield grew around the church of St Laurence and for over 1,000 years enjoyed a peaceful and uneventful history, remaining, until the late nineteenth century, a farming community. By the fourteenth century a gradual revolution took place and the lord of the manor ceased to be the feudal lord, becoming more like a landlord. The land was leased to yeomen as free tenants and Northfield was divided into many small farms. In 1851 there were fifty-two farms in the parish and even as recently as the 1960s several farms were still working, of which only one remains today. Stories have evolved around some farms such as the one surrounding Tinker's Farm, which was reputed to be haunted. In the eighteenth century a farmer lived there with an attractive young wife. His handsome young farmhand fell in love with the wife. Before long the farmhand disappeared, the farmer explaining his absence by informing local people he had returned to Ireland. When the farm was eventually demolished it is said human bones were found at the bottom of the well. Beryl Percival recalls a farm in Middlemore Road where, in the early 1940s, it was rumoured that flashing lights had been seen coming from the windows during the blackout. She was uncertain about the truth that the police arrested Nazi sympathisers after these incidents, but it became the high topic of conversation among the local juvenile population!

The past ninety-two years have seen Northfield absorbed into the urban sprawl of the City of Birmingham. It is no longer a village, more a town. Family-owned shops no longer serve its people – they serve themselves – traffic has clogged the main street, and according to new proposals it will soon be bypassed altogether!

As long ago as the early 1920s the Civic Society proposed a bypass to the Bristol Road. This was to cross what was then open land just to the north of the parish church along the line of Heath Road South and Great Stone Road. It was also proposed that from the station to Bristol Road, Church Hill be straightened and widened and driven through the old school buildings and the nailers' cottages behind the Great Stone Inn, to meet the proposed new bypass in a five-way crossing at the corner of what is now Church Road and Great Stone Road. The Society reported that 'The only buildings affected by this new route are the schools and a few cottages; and none of them is of great importance'. This was their attempt to justify demolition, which would have radically altered what is now 'the Conservation Area', and which fortunately today would be unthinkable. Since then several proposals have been put forward for a bypass, none of which has come to fruition, but with the new plans for revitalising Victoria Common and the village centre, together with the increase in traffic on Bristol Road South, which in 1971 was reported to be used to its full capacity, it does seem likely that renewed plans for a long overdue Relief Road will now go ahead.

1

Past & Present

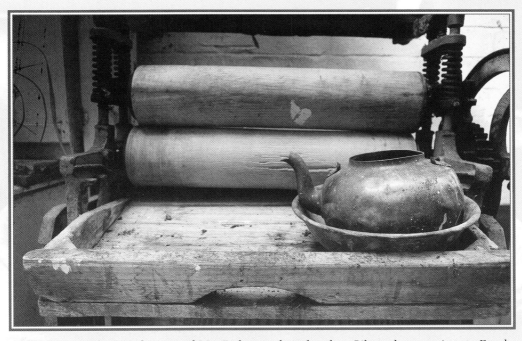

A wooden mangle given by Mr and Mrs Pickett to their daughter Lily on her marriage to Frank Neale in 1919. The Neales moved to Heath Road South, Northfield in 1936 and the mangle is still in use, by their son Eric, to this day. (*E.J. Neale*)

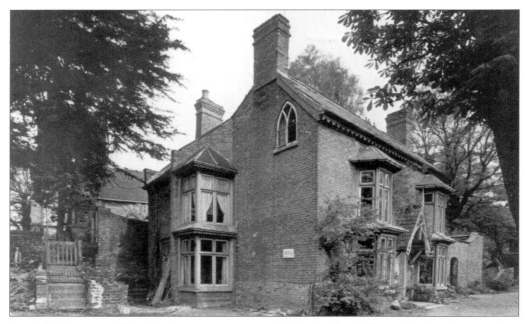

Curate's House – a Victorian house, once occupied by the Revd Henry Clarke who served as curate and rector of Northfield for fifty-one years until his death in 1880. A memorial cross to him was erected in the churchyard in 1884. The house was described in the 1881 Census as Church Cottage. At that period it was occupied by Evan Williams, Curate in Charge of Cofton Hackett, his wife and four children, a cook and a nurse – a somewhat sizeable cottage! We believe the last occupants were Stefan and Amy Hernicks, two Ukrainian Refugees, but the house was empty for some while prior to demolition. (*Northfield Library*)

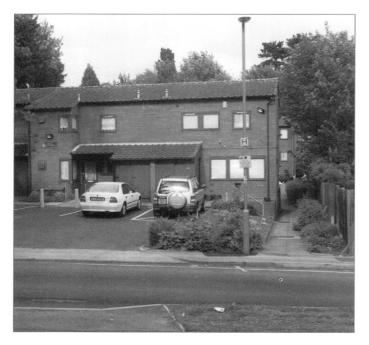

Bishops Court, Church Hill, May 2002. The church owned the land on which the Curate's House stood. In the early 1970s the Trident Housing Association wished to build warden-controlled flats on the site and negotiated with the church to acquire the land. It was agreed that in exchange for Trident building a new rectory, and converting the old one into a Pastoral Centre for the village, they could have the land. The Curate's House was demolished in 1973 and Bishops Court built in its place. (*J. Smith*)

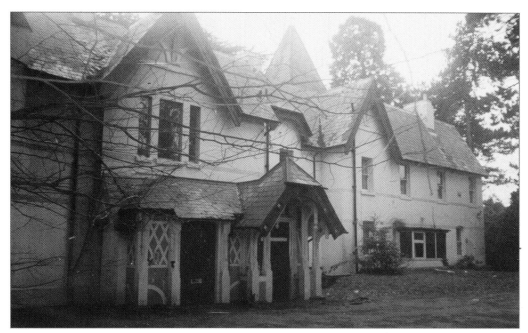

Ley Hill House, Merritt's Hill, 2002. This three-storey, 150-year-old Victorian building of great beauty has been occupied by both the Palethorpe (of sausage fame) and Kunzle (of cake fame) families, and has been described as a 'jewel' of the city's architecture. The house was left to the City Council for the benefit of local people by the Kunzle family in 1952, and was used as a Neighbourhood Office, but after allowing it to fall into a dangerous state of disrepair the council demolished it in April 2002. Local people are concerned that this will also mean the uprooting of a number of old and well-established trees surrounding the house, many originally planted by Charles Henry Palethorpe. (*J. Smith*)

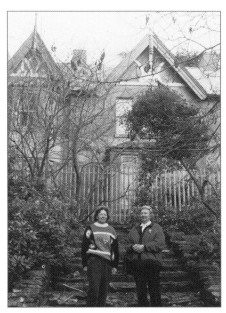

Charles Henry Palethorpe's two granddaughters, Dawn and Jill, both international show-jumpers who rode for Great Britain, outside Ley Hill House, 2002. Dawn, who was a reserve for the Stockholm Olympics, rode in the Rome Olympic Games in 1960. Charles Henry's father, Henry, who developed his own highly successful world-famous Royal Cambridge sausage recipe, established the firm of Palethorpes in 1852. Following his death in 1880 Charles Henry ran the company. A former brewery in Tipton was bought and transformed into a model sausage factory where production began in 1896, by which time Palethorpes were the largest sausage manufacturers in the world. It was over the next few years, as sales trebled, that the family lived at Ley Hill House. (*J. Smith*)

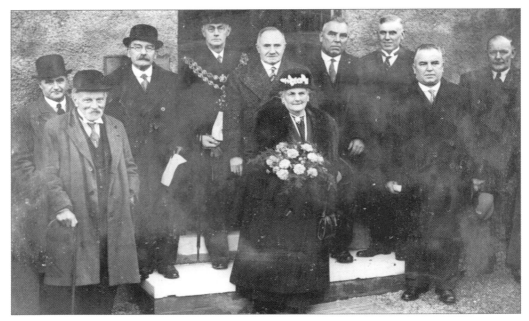

Above: Opening of the Sons of Rest shelter, Victoria Common, 5 December 1935. Left to right, Mr White (secretary, Parks Committee) Mr Clarke (member of Sons of Rest), Ald. Lovsey, Lord Mayor, Ald. Gelling (chairman, Parks Committee) Mrs Hodge, Coun. W.T. Hodge, W.G. Hodge, A.C. Hodge, Mr Morrison (Superintendent of Parks). In 1927, a few 'industrial veterans' met regularly in Handsworth Park, to discuss the affairs of the day or recount memories of the past. As numbers gradually increased it was decided to form an organisation, resulting in the 'Sons of Rest' movement. In 1930, with the interest of the public and the Parks Committee aroused, a shelter for the use of members was established in Handsworth Park. The movement grew rapidly and shelters were provided in twenty-nine parks and recreation grounds throughout the city, many as a result of generous gifts, such as that of the Hodge family. Here men aged sixty-five or over could meet for a cup of tea, a chat, a game of chess, cards or dominoes, or an occasional concert or lecture. In their heyday the various branches represented 3,000 members and a further federation evolved known as the City of Birmingham Federation of the Sons of Rest to unite the various movements. The movement had its own anthem and initiation ceremony for new members. It spread to all parts of the country, with enquiries being received from abroad about the activities and running of the organisation. (*Northfield Sons of Rest*)

Frederick Malachi Hands' grocery shop on the corner of Chatham Road and Bristol Road South, *c.* 1897. Dorothy Hargest recalls cheese, butter, tea, sugar and other groceries being individually weighed out on the counter in front of the customer, wrapped and made into a neat package, the sugar always in blue paper bags. (*D. Hargest*)

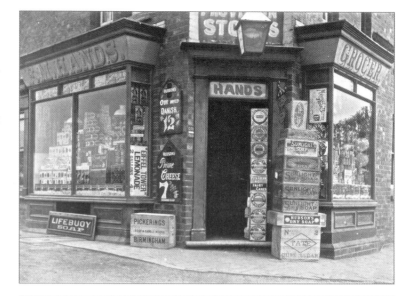

The Clock Café occupies the same site today. (*J. Smith*)

Opposite: The Sons of Rest shelter on Victoria Common, 2002. It still bears the inscription, 'This building, for the use of the Northfield branch of the Sons of Rest, was erected and presented to the City by Messrs W.T. Hodge, W.G. Hodge and A.C. Hodge and opened by the Lord Mayor (Alderman S.J. Grey, JP) on the 5th December 1935.' During recent years, with changing patterns in lifestyle and retirement age, the need for such an organisation has declined and today only about seven groups remain. The basic maintenance, lighting, heating and upkeep of buildings is borne by the City Council but the members are responsible for the administration and day-to-day running, which, as Tom Ryan tells us, needs to be on a very strict basis in order to keep the discipline for maintaining the billiard tables in tip-top condition. At Northfield each member pays an annual subscription towards costs of light refreshments and upkeep of billiard tables. (*J. Smith*)

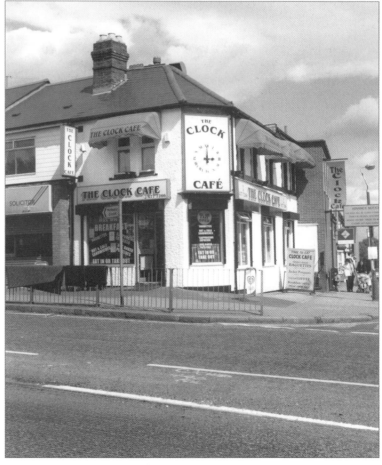

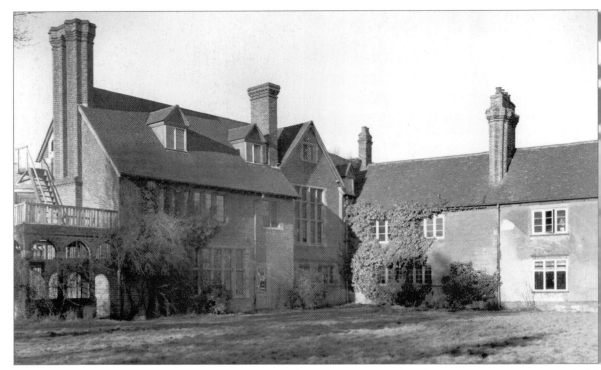

The Grange, built between 1500 and 1550, was for many years a farmhouse. Its appearance in 1955 hardly differed from that in the late sixteenth century. It is thought to have been built by monks of Halesowen Abbey, for records show that the Abbey held granges at Warley, Dodford, Harborne and 'one south of Halesowen, on Pigeon House Hill'. The back portion included a group of Elizabethan chimney stacks, which, prior to demolition in 1964, descended below roof level. Examination by historians revealed that at one time the building was of only two storeys – one of which was in the roof. At some stage a third floor was added and half-enclosed the stacks. Dormitory windows were added during the early seventeenth century. (*Birmingham Central Library – Local Studies Dept*)

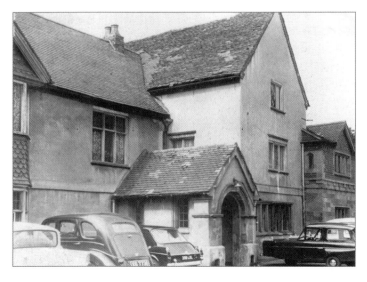

The front entrance porch, September 1964, through which one entered by means of an old oak, studded door. The Grange, described as 'the most interesting house in Northfield', was originally noted for some fine woodwork. It is believed that it was once home to a French family, as during the redecoration of a bedroom many years later French newspapers were discovered lining the walls. It was surrounded on three sides by a moat, which, before being filled in in the late nineteenth century, was graced by four fine swans. The red sandstone rocks cropping out on to the fourth side, in Bristol Road, provided adequate defence on that quarter. (*B. Mason*)

Longbridge Social Club, at the opening night of the new building in the Concert Room. The second lady down, Mrs Taylor, is the wife of Dan Taylor, the secretary. In the front row is Albert Smith (secretary after Dan Taylor), and his wife. In 1917, after being sacked from his job at the Austin Motor Co., Harry Stubbs founded a Social Club in an old barn on the Longbridge Estate in the shadow of the Austin factory. As intoxicants were not allowed on the premises a new club was built in 1928 with aid from a brewery. Harry was elected trustee and chairman in 1929. In 1933 he was elected president, an office he held until retirement. Because of further problems with premises, the club moved first to an empty house in Tessall Lane, then, in 1946, it was decided to buy The Grange. Initially an improvised bar was set up with an old coke stove for heating until 1965 when the club was rebuilt. (*B. Mason*)

The Longbridge Social Club as it looked in 2002. Dan Taylor recalled how many men had told him, when serving abroad under bad conditions in the Second World War, their thoughts took them back to the pleasant evenings spent in the little house on the corner of Tessall Lane, drinking pints of cool beer with their friends. After the war membership rapidly expanded, necessitating larger premises, and The Grange was acquired for a sum of £3,000. By the 1960s The Grange had become so infested with woodworm that the damage was irreparable, it was demolished and so replaced with the present building. By the 1970s the Club was one of the most affluent on the Clubs and Institute Union list. (*J. Smith*)

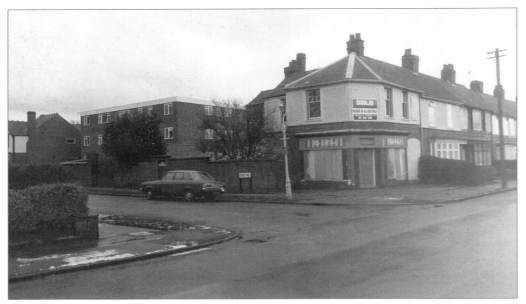

No. 123 Mill Lane stands on the corner of Mill Lane and Steel Road, and was built as an end terrace shop. Karan and Phil Jones bought the property from Ansells Brewery soon after it ceased trading as an off-licence in 1979. They were looking for a first home with character, challenge and space for a workshop and 123 fitted the bill perfectly. (*G.O. Jones*)

They felt certain that the property was built as an off-licence. The cellar had a raised platform along each wall so that barrels could be dispensed into a jug, beer being sold by the jug in those days with customers having to supply their own receptacle. The photograph shows the slope down which the barrels were rolled when deliveries were being made. (*P.K. Jones*)

Part of the substantial brick-built outbuilding, which was in the back yard and housed a stable, storage for a cart and a washhouse. Presumably beer was originally delivered to the surrounding area by horse and cart. During the time Karan and Phil lived there they extensively refurbished the property, converting the shop into more homely accommodation. (*P.K. Jones*)

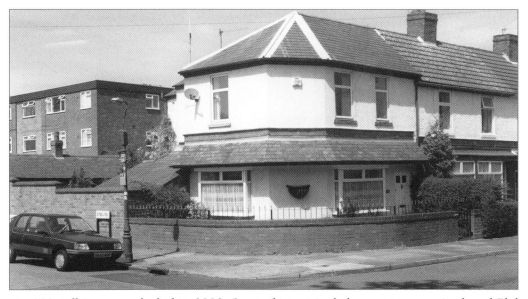

No. 123 Mill Lane as it looked in 2002. Some of its original character was retained, and Phil recalls, when removing a mock fireplace with tiled surfaces extending on either side which had probably been installed in the 1960s, they found that most of the structure was supported by large one-gallon beer cans – unfortunately empty! They spent sixteen happy years there before moving to Wales. (*J. Smith*)

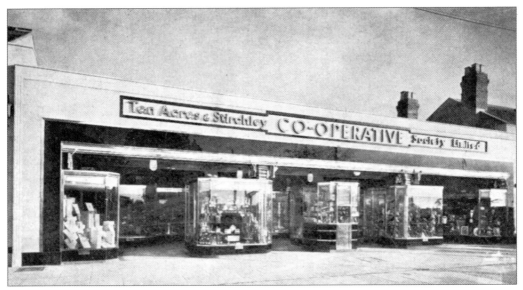

The Co-op Emporium, the large department store in Northfield to which a second floor was added in 1956, opened in 1937 and closed in 1985. The Ten Acres & Stirchley Co-operative Society Ltd was formed in 1875 and in 1950, when it was in its heyday, it became an important part of the life of the community in South Birmingham and the rural districts beyond; one of a thousand similar societies in Great Britain, the total membership of which exceeded 10½ million. Its catchment area comprised roughly three parliamentary divisions, Kings Norton, Northfield and Bromsgrove, and parts of the Moseley and Edgbaston divisions. By this time one person in every three or four living in the area was a member of the society. The abbreviated title 'Tascos' was coined in 1927 for use in advertising, and soon became so popular the society was known far and wide by its shortened title. (*Co-op History Group*)

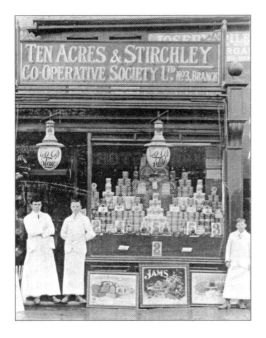

Exterior of Northfield Co-operative Grocery Store. In 1899 the Co-op came to Northfield when it opened its third grocery branch near the Traveller's Rest. This later transferred to a site halfway up the village, near Wheeler's Garage. As a protection for members, the only matches sold in the grocery department were safety matches! In 1905 deep stirrings of political unrest arose, prompted by a threat to the free trade policy of the country and, as this was six years prior to these districts being incorporated into the City of Birmingham, a motion was carried by the Co-operative Movement, to form a fund to support a candidate for the Kings Norton and Northfield Urban District Council. (*Co-op History Group*)

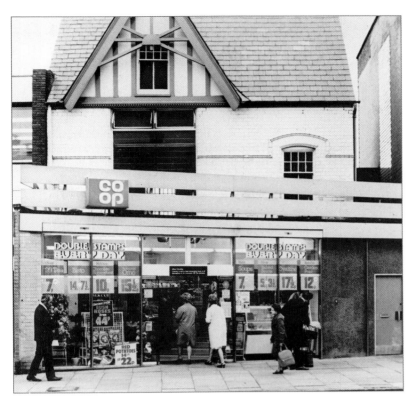

The Co-op shop at 768 Bristol Road South, 1972. It is now the Co-op Shop 'N' Save. Initially everything was done by the pioneers who founded the society, and who were prepared to turn their hands to anything. As they all had full-time jobs the original shop in Stirchley was only open in the evening from 6.30 to 9.00 p.m. and on Saturdays from 2 to 10 p.m. The pioneers often had to walk to town to carry back a side of bacon or other commodities, there being no transport in those days, and even when the bacon reached Stirchley it frequently had to be taken home to dry. Several times during the society's early history bad management and dishonesty by officials almost brought disaster, for co-operative societies in those days relied on the honesty of the members and staff. (*Co-op History Group*)

Allens Cross Co-op, currently Alldays which has just been bought by the Co-op, and which may soon be reverting to its original name. Tascos, one of the larger societies, showed an initiative and capacity for experiment which were nationally recognised. It was among the first to add departments in pharmacy, hairdressing, horticulture and funeral furnishing and, in accepting the social responsibilities of a co-operative society, was consistent and equally venturesome in its financial provision for education, youth work, adult and technical education. It had a range of twenty trading departments, including a number of productive factories and service departments, all controlled by the members through the medium of their own democratically elected board of directors. (*Co-op History Group*)

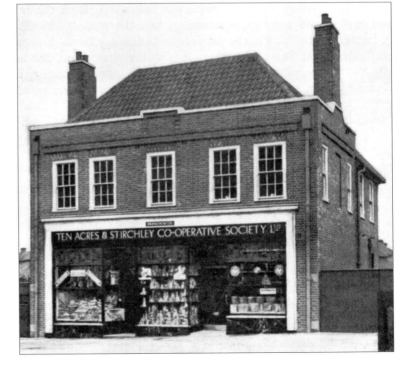

Thomas Pocklington, whose concern for blind people began when, as a young man, he temporarily lost his sight. When it returned he vowed he would help people with permanent sight loss. By prospering in his career as a watchmaker and silversmith he was able to fulfil this promise, and in his will he directed his trustees to set up a charity, which was established in 1958 as 'The Gift of Thomas Pocklington', with the aim of providing accommodation for the visually handicapped over the age of sixteen. Owing to his shrewd and far-sighted investments sufficient money became available for the provision, up to the present day, of five residential centres in the United Kingdom. These centres offer housing, care and support services to people with visual impairment. (*Thomas Pocklington Trust*)

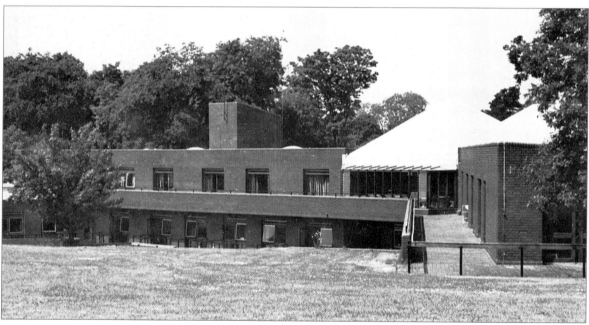

Pocklington Place, Northfield, which provides thirty-five residential rooms for the aged blind including those needing extra special care. Most of these rooms have their own balcony, toilet and washbasin and, in the case of special care residents, beds have access to sheltered balconies. In addition there are two respite rooms, forty sheltered flats, and two further flats have recently been converted into independent living flats. A Day Centre is also run by the staff, on site, three days a week, for visually impaired people from the local community, and it is hoped soon to expand services further to give assistance to people living in their own homes. The aim of the complex is to encourage visually impaired people to live as independently as possible while also providing extra care as the necessity arises. (*Thomas Pocklington Trust*)

The front of Pocklington Place, 2002. After the building of the second complex in Roehampton it became abundantly clear that accommodation for elderly people, in circumstances which preserve their independence is, in the majority of cases, a prerequisite of longevity. The trustees bore in mind this social change, and the need for greater medical care than was originally envisaged, when they planned Pocklington Place on its 3.5 acre site in Northfield. In planning so comprehensively it was hoped to allay the fears, which are always present with older flat dwellers, that when they can no longer look after themselves they must move to a totally new environment, at an age when making new friends can be a major problem. (*J. Smith*)

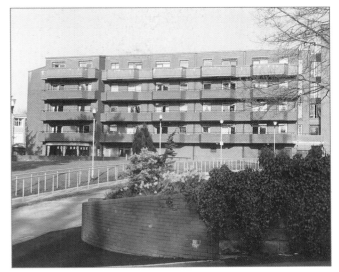

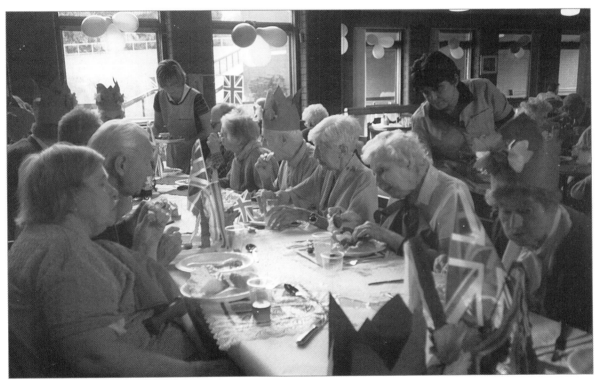

The Queen's Golden Jubilee celebrations at Pocklington Place, with most of the decorations for the celebrations being made by the residents in craft classes, June 2002. In the main core of the building there are two dining rooms plus provision for occupational therapy, chiropody and hairdressing, and a large shop for all residents and staff. Entertainments, talks, Bingo sessions, various classes and outings are also arranged for residents. The Chairman of the Trust today is Rodney Powell, son of John A. Powell, nephew of Thomas Pocklington, who was trustee of Thomas Pocklington's estate and a life trustee of the charity from its foundation, serving as its chairman for over twenty years. (*Thomas Pocklington Trust*)

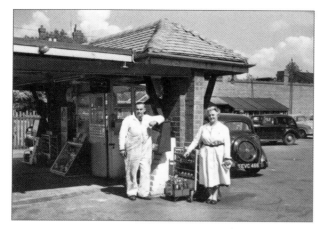

Albert and Marie Hadley at the Rex Garage, Bristol Road South, 1955. In his younger days Albert was a great athlete who ran for Birchfield Harriers. As part of his training, before going to school, he would run from Selly Oak to Longbridge and back again. (*C. Collett*)

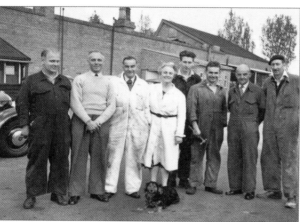

Albert and Marie with their staff at the Rex Garage. Albert was renowned among his staff as a very hard taskmaster but always perfectly fair. He began his working life at the Old Mews Garage at Kings Norton. He then moved to Tessall Garage where, in about 1946, he met with an accident falling down the pit backwards and severely damaging his back. (*J. Kirkham*)

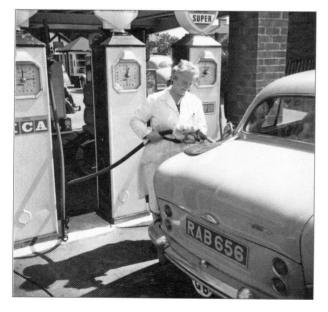

Marie at the pumps of the Rex Garage when petrol was served by a personal assistant. After his accident Albert was told he would never walk again. However, with his dogged determination and the help of an osteopath, this advice was proved wrong. Upon his improvement he started a car repair business in his own garden in Farren Road, calling himself Almar (part of Albert and Marie) Car Repairs. This business soon grew and he moved it to Longbridge Garage in Longbridge Lane where he worked in a bicycle shed, hired from Mr Phelps. When this became too small he rented a workshop at the Rex Garage from Alfred Shields, a pawnbroker in Selly Oak. (*C. Collett*)

The Rex Garage in its heyday – 1955. Through working all hours the business rapidly grew and Albert soon bought the whole of the site. In addition to the Rex he was approached by the owner to manage the Manor Service Station at Halesowen. This soon became equally successful, but when the bypass was built in the early 1960s it took away any passing trade and the business rapidly declined. (*C. Collett*)

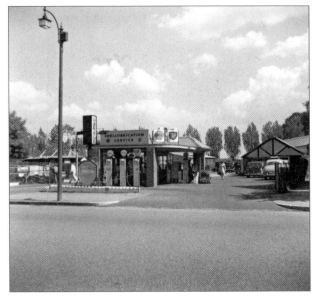

Albert Hadley's business card advertising the Rex Garage. Albert was a brilliant mechanic who would always find a way round any problem and refused to let anything beat him. During the Second World War he did a lot of work for the War Department, and it was quite a usual sight to see a tank trundling along the Bristol Road and entering the Rex Garage for repair. Albert closed and sold the Rex in the early 1970s owing to ill-health. (*J. Kirkham*)

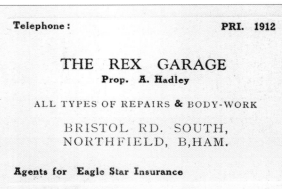

By 2002 the Rex had become a Total garage. (*J. Smith*)

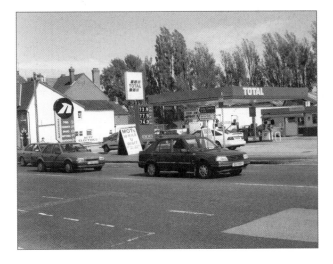

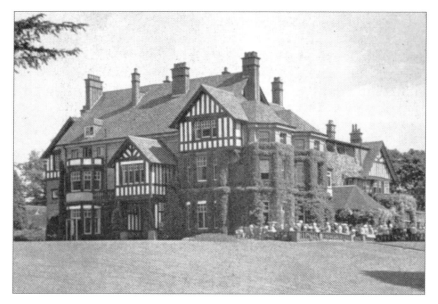

The Manor House, Northfield, August 1951. This was the home of George and Elizabeth Cadbury who developed the estate both as a working farm with produce serving all estate employees and some of the local community as well, and exquisite grounds graced by peacocks and swans. Through their benevolence many hundreds of children and adults were invited as guests to wonderful teas and to enjoy the amenities of the estate, consisting of boat trips on the lake, dancing on the tennis courts, angling, a coconut shy, football, cricket, rounders, an excellently laid out golf course of seven holes, open-air swimming bath, and, in the large barn, concave and convex mirrors making one look short or tall, stout or skinny. Visitors were also allowed the freedom of the house to view the beautiful pictures, listen to organ music played by Dame Elizabeth Cadbury, and to make use of the great variety of books in the library. All this left many people with very happy memories of wonderful times and the great kindness and generosity experienced on those trips. (*Cadbury Trebor Bassett*)

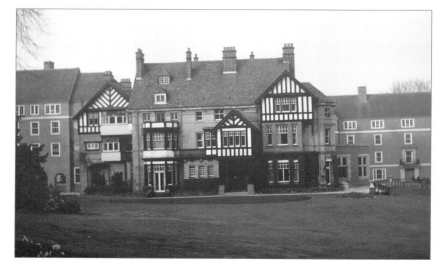

The Manor with added wings, seen in 1960. Under the terms of George Cadbury's will, on the death of his wife some 50 acres of the Manor grounds, including the lake, were to pass to the City for use as a public open space. The house and 12 acres of land were left to Birmingham University for the provision of student accommodation. In 1954 the Manor House was opened as a hall of residence and few alterations were necessary to house forty male students. The oak room, which later became the students' common room, contained Dame Elizabeth Cadbury's organ, which was subsequently given to King Edward's High School for Boys. (Sir Adrian Cadbury tells us that, as the organ was hardly used in the boys' school it has been moved to King Edward's High School for Girls where it is played daily.) In 1957 the east, and in 1958 the west wing, containing study bedrooms for 150 students, were added plus a block, built on the site of the summerhouse and kitchen/herb gardens, to house a further 150 students. (*J. & M. Glen*)

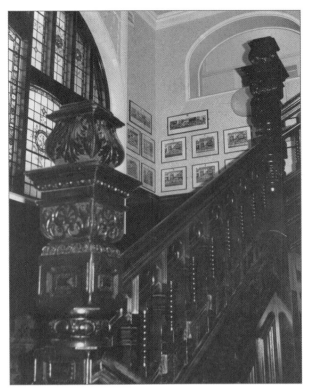

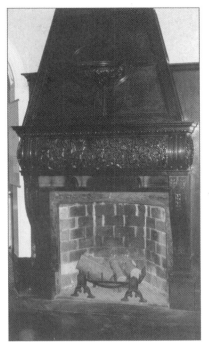

The oak staircase and fireplace, above which, carved in the wood is the comforting inscription, 'East, West, Hame's Best'. Following his purchase of the Manor George and his wife made some alterations and extensions. In 1943 Dame Elizabeth wrote, 'The main front rooms are part of the old building, the Library, the room we mostly live in, was two rooms made into one. We enlarged the room on the left-hand side of the entrance, pushed the hall back and made a new staircase, necessitating a new kitchen and other service departments. The attic floor we converted into several good bedrooms.' (*J. Smith*)

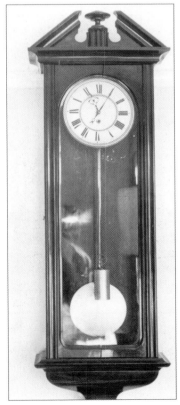

A clock purchased at auction by Gordon Jones when the contents of the Manor House were sold. During the Cadburys' occupancy of the Manor many famous people stayed there as guests of the couple, including Robert Baden-Powell, G.K. Chesterton, George Bernard Shaw, Emily Pankhurst, Henry Campbell-Bannerman who in 1899 became prime minister, Norman (later Lord) Birkett who worked as private secretary to George Junior (so called as he was the son of George and Elizabeth) while studying for the Law, Anthony Eden, the Duke of Kent and Theodore of Russia. (*G.O. Jones*)

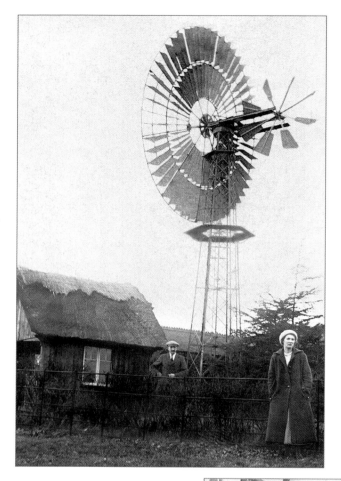

Charles William Barrett (grandfather) and Gertie Barrett (mother) of Bob and Wilf Barrett, *c.* 1923, by the windmill which was used to generate electricity for the Manor House. It is believed 'the Cadburys' were the first in Birmingham to illuminate with electricity from windmills, many of which were made at the Climax factory just outside Worcester, their purpose being either to pump water to a reservoir or to generate electricity. (*R. Barrett*)

The engine house containing the generator, switchboard, rows of accumulators and two dynamos, which supplied the current for the electrical power to the Manor and also charged batteries, which acted as back-up when wind power was not available, 1919. George Mason remembers that a few fields away there was another windmill which he thinks was for pumping water to Ley Hill House. It was situated near to Merritts Brook, but by about 1927 it was out of use and in poor condition. At a weekend camp organised for the Boys' Brigade he recalls tents being pitched very near to the windmill, and the boys climbing it. (*W. Barrett*)

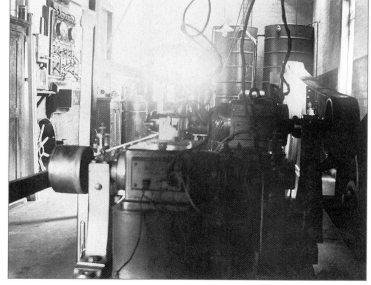

Charles William Barrett, who was joiner and general handyman for the Manor estate, outside his workshop, with one of his grandchildren. Prior to his job at the Manor Charles had travelled the world as a ship's carpenter. He made the boats to sail on the Manor Pool and many youngsters have enjoyed hours of pleasure being rowed across the lake by him. In fact he died in one of his boats while out rowing a party. Wilf Barrett remembers as a young child going into his grandfather's workshop where he was making wooden gun carriages for the cannon at The Davids (pictured in *Northfield Past & Present*). (*L. Evans*)

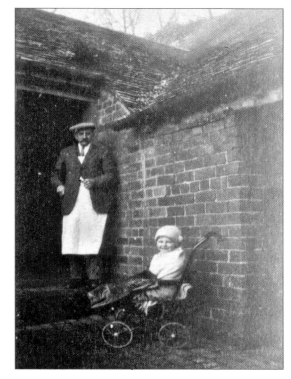

Windmill Cottage, on the Manor estate, was home to Charles William and Emmie Annie Barrett and their family. Seen here, *c.* 1918, are, left to right, George William, Emmie Annie, Emmie Maud Ellen, Wilfred Charles, Charles William and seated in front Sarah White, mother of Emmie Annie. (*L. Evans*)

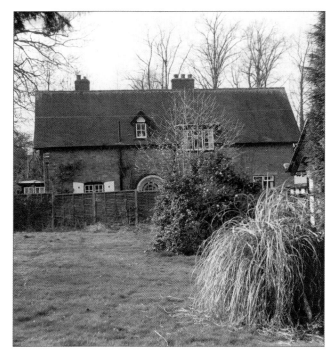

Rose Cottage, on the Manor estate, now occupied by the chef for the Birmingham University accommodation at the Manor House, 2002. Ken Mason, whose grandfather was gardener to Sir Henry Rider Haggard (author of *King Solomon's Mines*), tells us that when he was three he lived in the cottage at the end of the half-mile drive, as his father, Frederick, following his First World War posting at Hollymoor Hospital and subsequent demobilisation from the Royal Army Medical Corps, was appointed head gardener at the Manor, where together with eight other gardening staff, he managed the whole estate. Among many species of trees including a peach tree there was, in the hothouse, a cocoa tree, which in 1912 bore a cocoa pod of some size and several others of promise, a feat causing great pride as it was understood then that not even Kew Gardens had managed to produce one! (*J. Smith*)

Nos 3 and 4 Sunbury Cottages, 2000. George Cadbury believed that the improvement of housing for the ordinary working person was extremely important. Sunbury Cottages were typical of those on country estates in this period, and it appears the inspiration for building such accommodation followed his stay in a cottage in the Lifford area near Stirchley, where, in 1879, it was totally rural. They are also the first houses designed for George Cadbury that are properly set in a landscape, having an eighth of an acre each, and have, even today, thanks to the proximity of Victoria Common, an atmosphere of rural seclusion. Built of brick in semi-detached pairs, the half-timbering in the gables is imitation. Apart from this decoration the houses are plain, though there is a certain subtlety in the handling of the brickwork, the edges of

the buildings and lintels being given a curved profile by the use of bull-nosed bricks. These curved corners are common in farm buildings, where animals or carts might scrape against the walls, and is further evidence of the relation of the design to country estate cottages. Laundry was originally done in wash-houses which stood well away from the cottages at the foot of each garden. (*J. Smith*)

Snow in Hanging Lane when it was a very narrow lane with large rocks on either side, 1920s. The above scene is just before the junction with Tessall Lane, where there is now a roundabout. The cottage is in Tessall Lane. (*M. Royce*)

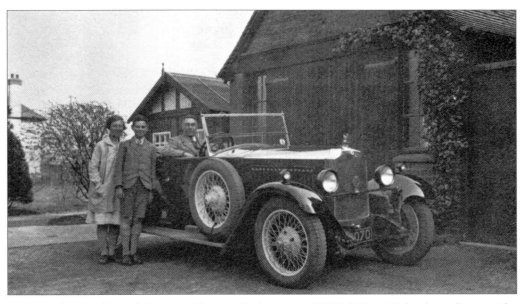

Dora, Michael and David Royce at Thorne, Cock Lane, *c.* 1925. When Michael was born at the house in 1915 it had mains water, but little else in the way of amenities. Oil lamps and an oil stove were used until the arrival of electricity in the early 1920s. When Cock Lane was renamed Frankley Beeches Road Thorne was given the number 153. In 1970 Michael sold the property and, together with his wife and son, moved to Bridgnorth, where he still lives. Following the sale Thorne, together with other houses in the vicinity, was demolished and replaced by modern housing. (*M. Royce*)

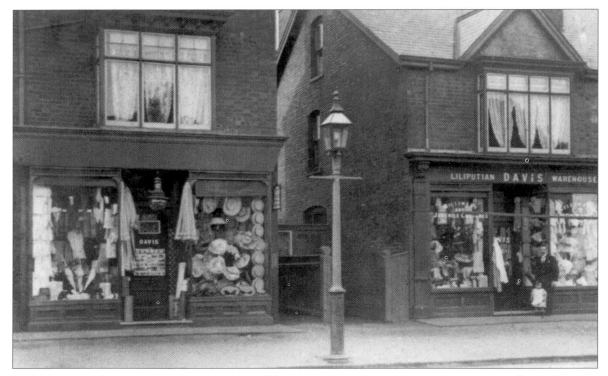

Davis' Drapery Shop in Bristol Road South had large counters with yard measuring strips. They sold cloth from the roll, buttons, ribbons, needles, threads and so on. One of the largest shops in the village in the 1930s, it boasted an overhead carrying wire, in which money was despatched to a cashier in a raised office, and was returned complete with change and receipt. Gerald Davis, the owner, was a well-known breeder of Sealyham Terriers and dog show enthusiast. Following the death of his wife, in the mid-1960s, he moved to Coombe Martin where he bought a smallholding and married a farmer's daughter. Sadly he died approximately six months later. Northfield used to contain several high-class drapery shops like Davis's, but with the trend to larger and more comprehensive stores these small, personal shops gradually disappeared. (*Northfield Library*)

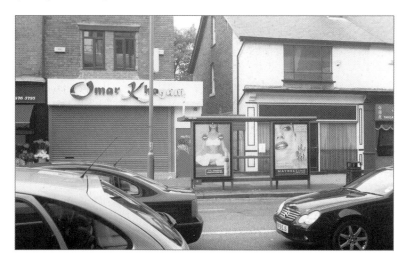

The same scene in 2002. Gone are the shops of character with their interesting window displays, staff who gave expert advice and took a personal interest in all their customers. Davis's is replaced on the left by Omar Khayam, serving Indian Cuisine, and on the right by offices for Morton's the Funeral Directors. To minimise any vandalism, many businesses use metal shutters for protection when their premises are closed. (*J. Smith*)

When Ann Evans and her
family came back from abroad
in 1975 and moved into a
house in Chesterfield Close this
was the view they had from
their bedroom window –
looking across fields, which
had previously been noted for
their numerous corncrakes
and where the vixen found
shelter for her litters year after
year. In 1975 it was still
farmland on which animals
grazed even though in the
distance could be seen the
high-rise blocks of flats in
Staple Lodge Road. These have
since been demolished.
(*A. Evans*)

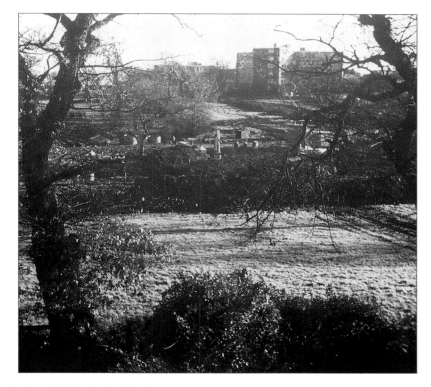

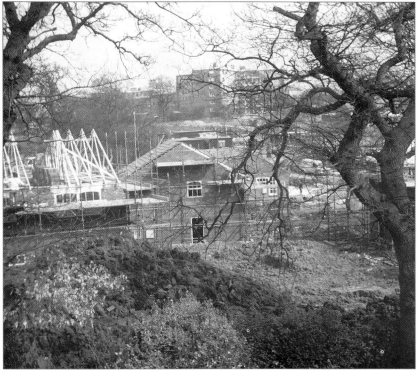

By 1840 the Gloucester to
Birmingham Railway had
been cut through the Rea
valley, although there were
no houses of any description
in the area up to 1878
(after which date The Ericas,
Wych Elms, Old Court, and
Alveley were built). The
nearest houses were
Northfield Rectory and the
cluster of nailers' cottages
around the church,
Staplehall House, Wychall
Farm and Middleton Hall.
By 1981 the land seen
above had been sold and an
estate of mixed residential
accommodation was being
built. The houses being
constructed on the right are
in Over Brunton Close.
(*A. Evans*)

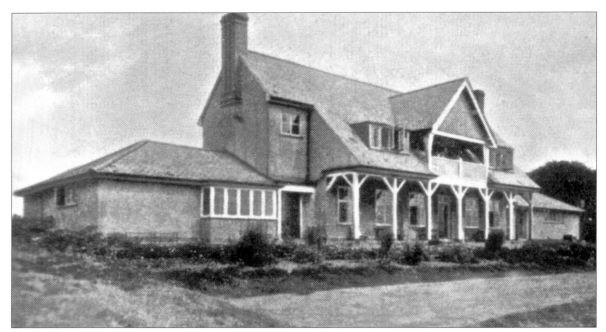

The Clubhouse at the North Worcestershire Golf Club, 1925. Northfield Golf Club owes its existence to the generosity of Edward Cadbury who, in 1905, allowed people to use his private nine-hole course at Woodbrooke. This proved so popular that after three months Mr Cadbury was forced to withdraw the privilege. However, enthusiasm for golf had been aroused and an approach was made to Thomas Quinney as to the possibility of using land on Mason Leys Farm. A lease was arranged for sufficient land for a nine-hole course on condition that no hedges were cut, there should be no Sunday play and no dogs should be allowed on account of the grazing of sheep over the land. Thus the Northfield Golf Club was formed. In 1909 James Braid, then reigning champion, devised a first-class nine-hole course, with an approximate length of 3,000 yards. The holes then laid out form part of the present course, and include the famous 'Sand Pit'. Braid later extended the course to eighteen holes and, although many improvements have since been made, the general layout remains as originally planned. (*The North Worcestershire Golf Club Ltd*)

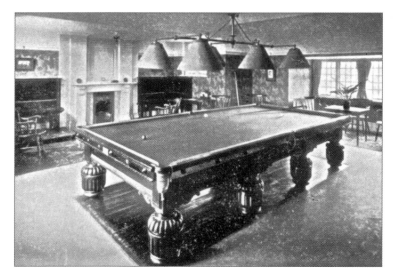

The Billiard Room. The present Clubhouse was erected and opened in 1919 and over the years has been considerably extended. It is now an imposing building containing a spacious lounge and dining room, in which concerts and dances are held in the winter months, a billiard room and a separate card-room. The ladies have their own private lounge. Even if, by reason of inclement weather, golf is impossible, there is every opportunity to pass a pleasant social time, and many Midland golfers have recollections of happy days spent at Northfield. (*The North Worcestershire Golf Club Ltd*)

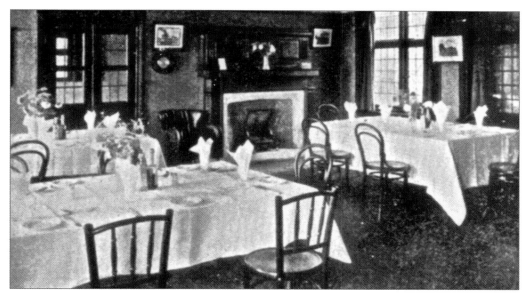

The Dining Room. The year 1909 was a turning point in the history of the club. Encouraged by the continuous growth of the membership, the Committee took the bold step of purchasing the freehold of the links, and the club became the proud possessor of 87 acres of admirable golfing land. As membership continued to grow it gained in importance, becoming the nursery of many good players and taking its place among local golf institutions. In 1911 the club was formed into a limited liability company and the name was changed to 'The North Worcestershire Golf Club Limited'. (*The North Worcestershire Golf Club Ltd*)

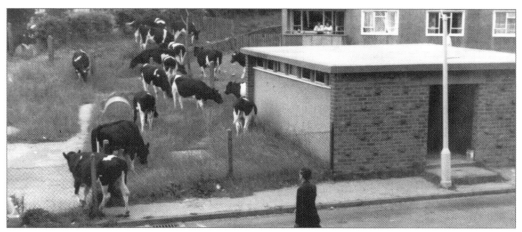

Cows at Ley Hill outside the front of Padbury House (81 block) in the 1960s. For thirty-eight years Martin Smith was caretaker of the blocks of flats at Ley Hill. He was based in Padbury but, with two assistants, was responsible for looking after all six blocks which were erected in 1956, each holding twenty-four flats – sixteen one-bedroom dwellings and eight with two bedrooms. The flats, and most of the adjacent housing, have now been demolished and Prime Focus has been appointed social landlord and regeneration manager to oversee the replacement housing. The intention is to maintain some of the wonderful views opened up by pulling down the estate and to rebuild without trying to cram in as many abodes as possible. The plan is to build 100 rental properties, 60 part-buy dwellings and 240 private homes. (*M. Smith*)

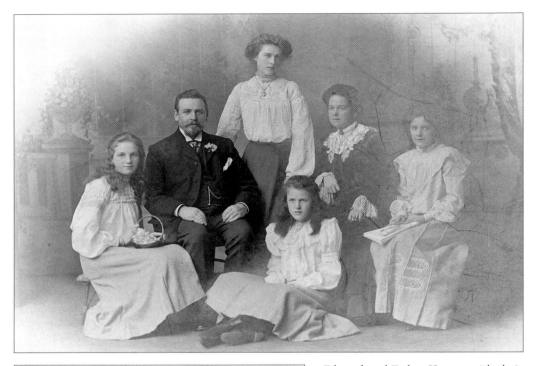

Edward and Esther Harper with their four daughters, *c.* 1900. The family lived at The Meadows, a beautiful black and white house in Bristol Road South, on the site now occupied by The Meadows School. Back row, left to right: Lilian Clarice, Edward, Annie Elizabeth (Betty), Esther (née Righton), Edith Mary. Front row: Helena Maud (Nellie). (*P. Evans*)

The front porch of The Meadows. Edward and Esther were Pam Evans' grandparents, and Pam has very happy memories of visiting the house in her younger days. Edward died in 1940 and Esther continued to live there until her death in 1943. Up to that time its sole use had been as a private residence, but following her death the house was sold to be used as a hostel for apprentices from the Austin Motor Co. and then for a variety of purposes before its demolition in the 1960s. (*P. Evans*)

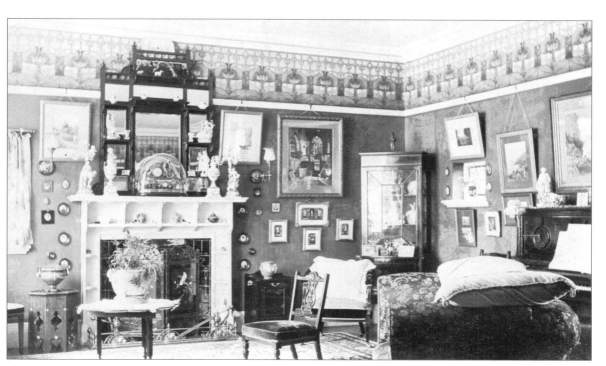

The drawing room at The Meadows. The large painting on the wall to the right of the fireplace was willed to Helena and then to Lilian's daughter and is still in her possession today. (*P. Evans*)

Edward Harper, a very keen gardener, at The Meadows, *c.* 1930. During his occupation the grounds were always kept in an immaculate condition. (*P. Evans*)

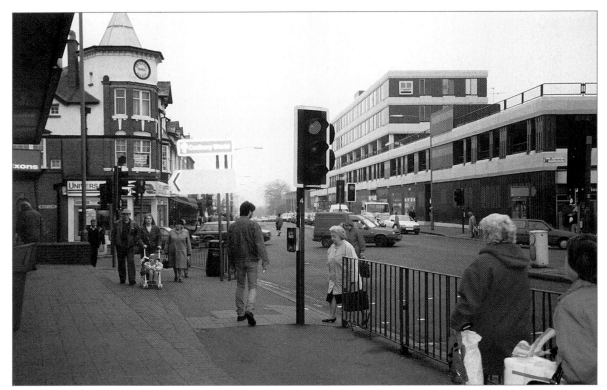

The Grosvenor Shopping Centre. The basement originally housed a 'dive bar' public house, The Dukes, accessible from Bristol Road South and run by Allied Breweries. Extensions to the centre were originally planned in 1973 to include a cinema, restaurant, a five-storey office block, extended car park facilities and an extension of 10,000 square feet to the Sainsbury's store. The project then priced at £2 million ran into a series of delays and difficulties including the fact that the developers, Grosvenor Estates Commercial Development Ltd, did not own the entire site. Because of this work did not begin until 1981 on a more modest scale. Major tenants now include Iceland, Dorothy Perkins, W.H. Smith, Walter Smith (butchers), Three Cooks and Superdrug. (*A. Evans*)

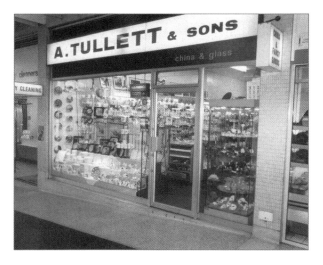

A. Tullett & Sons, high-class glassware and china, which was one of the original shops when the Grosvenor Shopping Centre opened, traded there until 1992. Tulletts is an old established business, which is still run as a family concern. Archibald Tullett, the grandfather of Peter who managed this shop, and Colin who manages the Shirley shop, started the business by running a market stall. In 1891 he opened his first shop in Aston, then moved to Moseley Village, Moseley Road, Hall Green, and Sparkhill. Tulletts still have a shop in Bromsgrove. Up to the 1920s, when large dinner parties were all the vogue, Tulletts only sold tableware. However, goods such as cookware, cutlery and tableware were available for hire. (*C. Tullett*)

The Northfield branch of W.H. Smith in the Grosvenor Shopping Centre, after refurbishment. Henry Walton Smith and his wife Anna opened a small news-vendors in Little Grosvenor Street, London, in 1792. The enterprise, then trading as newsagents and stationers, changed its name to W.H. Smith and Son when the founder's son and grandson went into partnership. The business opened its first bookstall at Euston on 1 November 1848 and other station bookstalls followed to take advantage of 'railway mania' in England. In 1860 the firm acquired its own printing works, and a lending library was started which lasted until 1961. W.H. Smith II became an MP and in 1874 retired from active partnership to devote his time to politics. Benjamin Disraeli made him First Lord of the Admiralty, an appointment satirised by W.S. Gilbert in his libretto for *HMS Pinafore*. In 1905 a dispute with the railways over bookstall rents resulted in certain contracts being lost and the firm reacted rapidly by opening shops near stations. Within three months 150 new shops came into being. The Smith family involvement with the management of the company ended in 1996. (*W.H. Smith plc*)

Julie Chapman opening the Northfield branch of W.H. Smith following its one-week closure for refurbishment in 1998. Julie was invited to cut the ribbon, as she was the longest-serving member of staff. The Northfield store was one of twenty-two trading as Preedy's, which were bought from Next plc by W.H. Smith. Julie began with two weeks' work experience for Preedy's in July 1986 and returned to work there in November 1988 after W.H. Smith had taken over. She worked on the Thorntons counter prior to gaining experience in all departments, and in October 2001 was appointed Store Manager. (*W.H. Smith plc*)

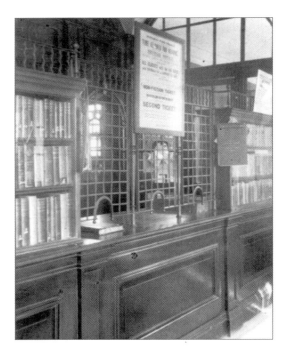

The counter at Northfield Library *c.* 1913 – a nice welcoming scene! Since the library was rebuilt in 1914, following the fire, it has been extended twice, the most recent alterations being in 1984. To celebrate the eightieth anniversary of its original opening a series of events took place at the library during September 1986 (see below and opposite). (*Northfield Library*)

The 3rd Birmingham Brownies learned how to use traditional toys and practised several singing rhymes in order to perform them in the library and to encourage other children to take part. St Nicholas's Theatre Group performed two short melodramas, the Northfield Adult Education Centre arranged a series of demonstrations of traditional crafts and The Birmingham Group of Cheltenham and Stratford Railway Society mounted a display of model railways. (*A. Evans*)

The 'Edwardians' and Alf White, a local group who regularly entertain with songs and monologues, performed in the meeting room to a large audience. Ron Daniel and Barbara Clews sang Edwardian songs, Joan Daniel performed monologues and the trombonist was Alf Watts. (*Northfield Library*)

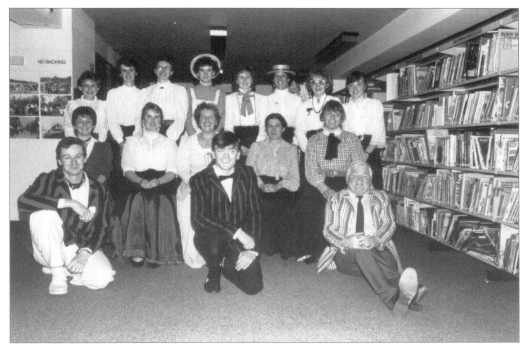

The library staff also dressed in Edwardian costume for the event and here we see in the back row, left to right: Cara Bough, Naomi ?, Susan Teckoe, -?-, Julie Shakeshaft, Jacky Chapman, Beverley Bache, -?- . Middle row: Lynn Fulford, Jacquie Deeley, Pauline Caswell, Linda Shepherd, Wendy Hadley. Front row: Keith Buckley, James ?, Mr Adams. (*Northfield Library*)

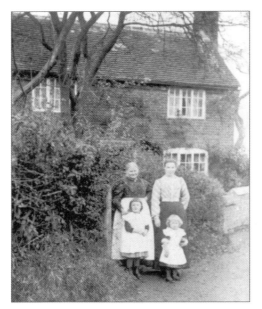

Paradise, one of a group of four cottages on the Turnpike, later Bell Hill, which had previously been the workhouse and gaol but were converted into cottages in 1820. Seen here in 1905 are Harriet Hemus with her daughter Ada Brown and Ada's children, on the left Eunice, born 1900, and Arthur, dressed like a girl, as was the custom in those days. Donald Cook, the son of Eunice, was born here and lived in the cottage until 1938. Originally the cottage was lit by an oil lamp, water was drawn from a well in the backyard and when this was dry it was carried from Merritts Brook. An outbuilding held a two-seater lavatory and the rent was 2s 6d a week. Paradise Cottage was demolished in the 1950s. (*Northfield Library*)

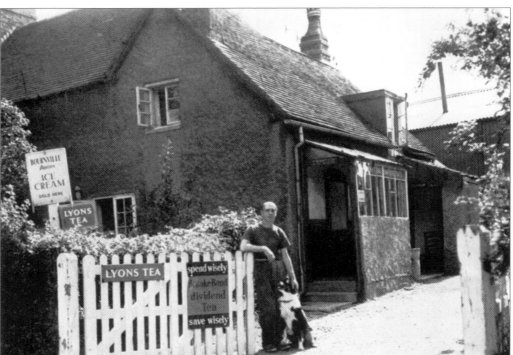

Leonard Seabourne, with his dog Bob, outside his cottage shop in Merritts Brook Lane, 14 August 1952. In about 1942 Norma Snell's parents moved to live in this cottage from where her father ran the pig farm and her mother ran the shop. It was a very small store and was entered from the side with goods being sold through a small window. It sold everything from needles and thread to food. However, in 1953 Birmingham Council compulsorily purchased both the shop and farm and built multi-storey flats on the land. (*N. Snell*)

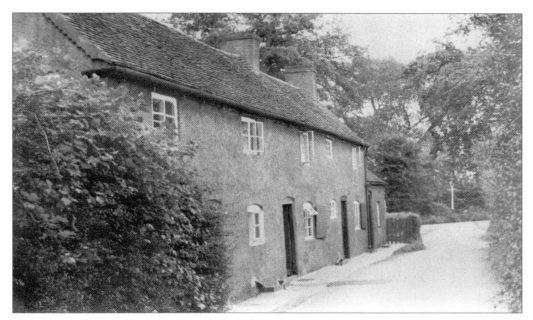

Cottages in Merritts Brook Lane, 1950s. In the seventeenth century Merritts Brook was divided from Paradise by a field path and all the cottages in this area had nail-shops attached. Today only two cottages remain. Rhoda Ricketts and Gladys Callow (members of the Niblett family), who lived nearby, recall how in their early years children were bathed before the fire in a tin bath, which had to be filled by hand. Rhoda and Gladys remember how they thought they were in heaven when they moved to a house in Allens Farm Road containing two main rooms and an upstairs bathroom with running hot water. (*G. Callow*)

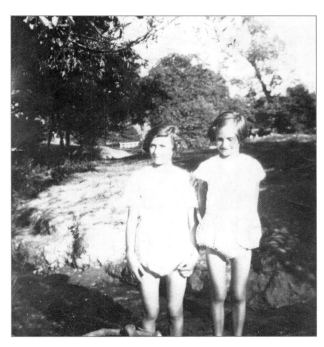

Joan and Irene Niblett paddling in Merritts Brook, *c.* 1935. As a special treat on fine days the Niblett family took a picnic down to Merritts Brook, following which they were allowed to paddle on the concrete square in the brook. (*R. Ricketts*)

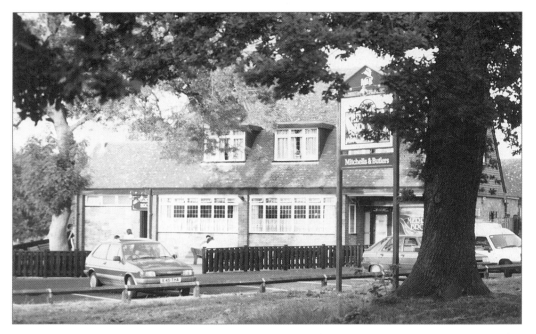

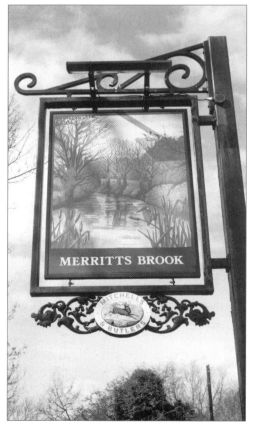

Built in about 1962 just a few hundred yards from the heart of Northfield's busy shopping centre, the Merritts Brook pub was situated in Bell Holloway, a secluded corner of Northfield, which offered locals and visitors all the atmosphere of a village setting but all the convenience of an urban location. Named after the brook which runs nearby, the pub's steeply pitched roof and mellow brickwork gave the appearance of an earlier age. (*P. Grainger*)

In 2001 the Merritts Brook pub was totally destroyed by fire, which was attended by over forty firefighters; it was believed to have been started deliberately. In March 2002 the inn sign was the only remaining part, but by late April 2002 the sign too had disappeared. Ron Ryan took over as licensee in 1976 and together with his wife, Brenda, created a homely atmosphere, providing a friendly haven for the local community. In 1992 the pub was one of the finalists in the *Birmingham Evening Mail* Midland Pub of the Year competition for, together with other facilities, as one local put it, 'the beer is good and we don't get any trouble because of the way Ron keeps control'. As very popular licensees, Ron and Brenda remained at the pub for sixteen years. (*J. Smith*)

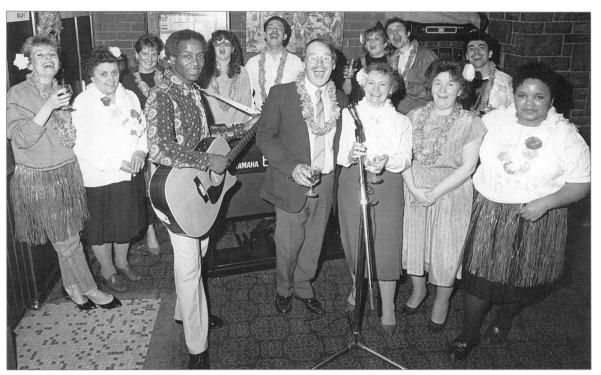

If money was ever needed for a deserving cause, Ron and Brenda's customers were always willing to help, and during their management approximately £10,000 was raised for equipment required for youngsters with special needs at the local Victoria School. A variety of fund-raising events were organised including a Caribbean Night, seen here *c.* 1991. (*R. Ryan*)

On the left Ron and Brenda are seen handing over a cheque for £1,200 to Victoria School's headmaster, Ian Glenn (right). The money was used to help convert an old hall into a theatre, and was raised by the regulars from a fancy dress evening, a car-washing day, pool competitions, raffles and a no-change day. Following his impressive record as a charity worker and one of Birmingham's longest-serving pub landlords, Ron retired in 1992 after thirty years in the pub trade. (*Ivanhoe Photography*)

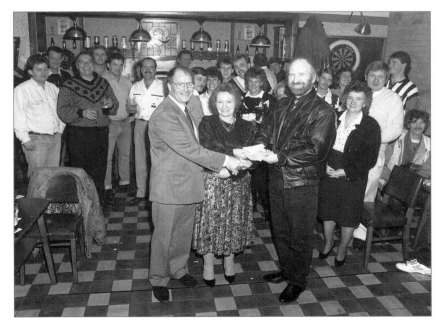

Right: May 2002 – Queen Victoria pillar-box on the corner of Norman and Bunbury Roads. In Northfield we have examples of pillar-boxes from all six royal periods since 1852 and inspection of the base usually reveals the name of the casting foundry. Although belonging to the category known as 'anonymous', so called because few of them carried a maker's mark, the very weathered lettering on this Victorian box appears to bear the name Hanoyside & Co. Ltd, London. (*J. Smith*)

Far right: May 2002 – Edward VII pillar-box at the corner of Woodlands Park and Bunbury Roads. This box used to bear an enamelled top sign indicating the direction of the Post Office in Heath Road. Some boxes had a stamp vending machine attached, which the Postmaster-General officially sanctioned for use in 1889, initially in London, but by the 1890s for general use throughout Britain. (*J. Smith*)

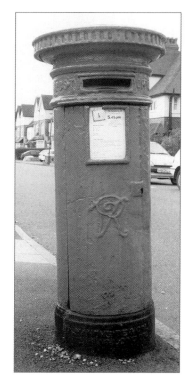
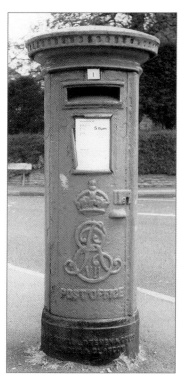

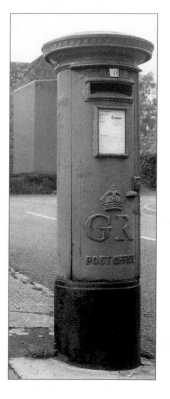
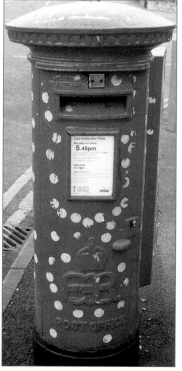

Far left: May 2002 – George V pillar-box in Cornfield Road. In 1851 Anthony Trollope, who was a surveyor's clerk before becoming a novelist, went to the Channel Islands to inspect their postal services. In St Helier, Jersey, as there was no post-receiving office, he recommended the use of street-side receptacles for letters, and the first British pillar-box was installed there on 23 November 1852. From 1853 similar boxes appeared on the mainland, London receiving its first six in 1855. They can be dated to a specific sovereign's reign by means of the cipher or monogram. (*J. Smith*)

Left: April 2003 – Edward VIII pillar-box in Middlemore Road, badly defaced. Even the short reign of Edward VIII provided examples and altogether some 217 made their appearance in 1936 before his abdication. (*J. Smith*)

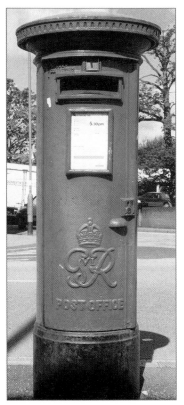

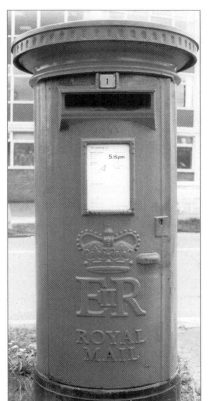

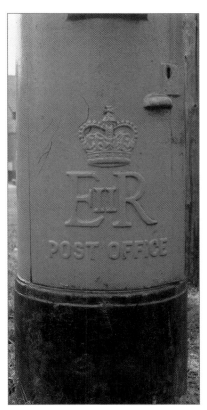

August 2002 – George VI pillar-box at the corner of Middlemore and West Heath Roads. By the late 1850s the number of pillar-boxes in England had risen to 703 and by 1861 some 2,473 had been installed. By the turn of the century 32,593 had been provided in cities, towns and even in rural localities. Since their beginning they have developed from a slightly mistrusted curiosity into one of the most familiar pieces of British 'street furniture' and a representation of the entire British way of life. Made of cast iron and initially presented in dark green livery, their scarlet and black appearance became standard in 1874. (*J. Smith*)

May 2002 – Elizabeth II pillar-box at the corner of Great Stone Road and Bristol Road South bearing the inscription 'Royal Mail'. Of all our pieces of 'street furniture' the pillar-box has changed the least with the passing years, only the royal ciphers having altered. Those erected for Elizabeth II's reign after 1952 looked exactly the same as those provided during the years of her great-great-grandmother Queen Victoria in the 1880s. Only very recently has a new design begun to appear. (*J. Smith*)

May 2002 – Elizabeth II pillar-box in Ingoldsby Road bearing the inscription 'Post Office'. Boxes were originally horizontal (some may remember the wall letter-box buried in the outer wall of the Great Stone Inn), the now familiar vertical shape appearing after 1856. The 'Times of Collection' plates only appeared as general features on all boxes after 1871. Today there are 115,000 pillar-boxes throughout the UK and they accept about 20 billion items of mail per annum. (*J. Smith*)

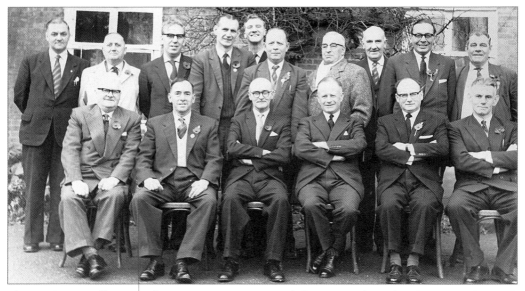

The 1959–60 Officers and Executive Committee of the Austin branch of the Royal British Legion, whose headquarters are in Quarry Lane, Northfield. Back row, left to right: R. Etherton, A. O'Connor (trustee), E. Becket, W. Chadney, T. Collins, H. Smith, J. Harrison, F. Snape, A. Bowater (trustee), C. Apperley. Front row: E. Johnson (pensions office), H. Collins (vice chairman), D.M. Brodie (chairman), J.W.R. Penrose (president), J.W. Weston (secretary), C. Court (treasurer). (*E. Collins*)

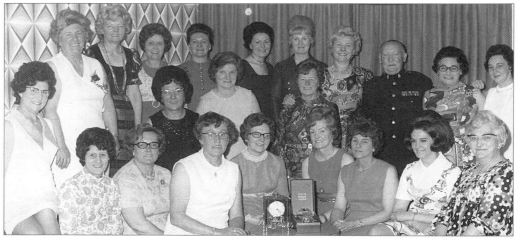

The Ladies' Section of the Austin branch, mid-1960s. Ellen Collins is on the extreme right of the front row and a Chelsea Pensioner is among the ladies in the back row. The Ladies' Section, with a membership of approximately seventy, met every Thursday evening for lectures, demonstrations and rehearsals for shows they produced in which both male and female members took part. Their prime aim was to raise money to help British Legion charities. All money raised was sent to the Pall Mall headquarters from where it was divided equally to all the Ladies' Section charities throughout the country. Concerts were also arranged with such notable entertainers as the Black & White Minstrels and Roy Hudd. Sadly, because of dwindling numbers, the Women's Section closed in about 1990. (*E. Collins*)

Remembrance Day Parade at the Quarry Lane Headquarters, *c.* 1970. The year 2002 was the eighty-first anniversary of the Royal British Legion when the Austin branch raised £11,172.30 for the Poppy Appeal. Since its inception in 1921 the 'Flanders Poppies' Appeal has helped to fund the Legion's work offering a caring service for the benefit of the ex-service community. Mrs Fern, Chairman of the Ladies' Section of the Austin branch, was poppy organiser for the Northfield area for twenty years, and for five years she collected the highest amount for poppy sales in the country. (*E. Collins*)

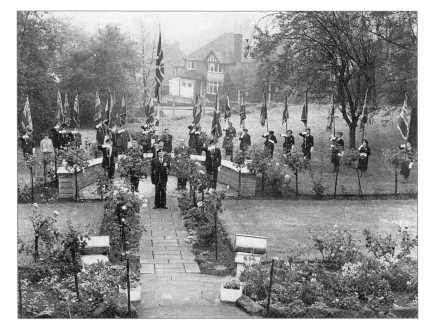

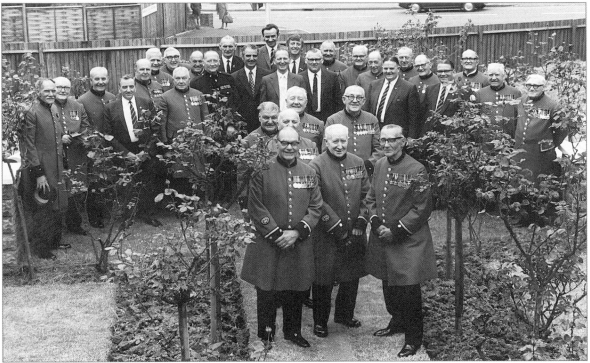

A group of Chelsea Pensioners visiting the Legion Headquarters in the late 1960s. Chelsea Pensioners made frequent visits to the Headquarters in Quarry Lane and reciprocal visits to the Chelsea Hospital were made by Legion members. The photograph includes Tom Collins, who was the Standard Bearer and held high office in the Legion, Eddie Dawes and Tony Hinton. (*E. Collins*)

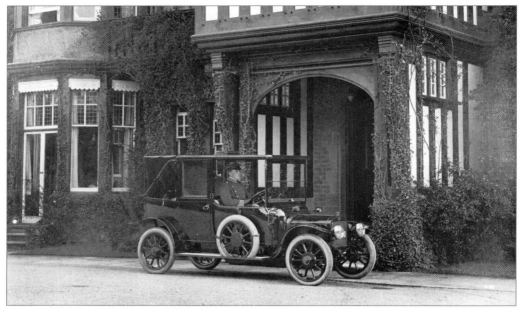

(Edward) Tutton, for twenty-three years chief chauffeur to Dame Elizabeth Cadbury until her death in 1951, awaiting passengers outside The Manor. Sir Adrian Cadbury recalls that in the 1930s his grandmother's car was a large, beautifully polished and cared for black and yellow Austin limousine. His sister, Veronica Wootten, tells us that in the late 1950s, when Shenley Fields was being developed by the Bournville Village Trust, a garage was considered necessary. The Trust agreed that Tutton should become the lessee, and the garage on Shenley Green be named Manor Garage (Northfield) Ltd. His daughter, Joan Carley, became Company Secretary and continued to run the garage for a time following her father's death. (*Sir Adrian Cadbury*)

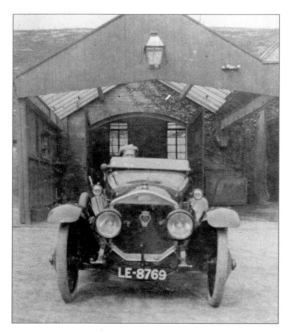

George Norman Cadbury outside the Manor in 1912 at the wheel of a Straker-Squire. Norman, the second son of George and Elizabeth Cadbury, was Chairman of the Electrical and Mechanical Brake Co., Manufacturing Engineers, West Bromwich. He was a competitor at Brooklands at the Easter meeting in 1912. Brooklands was built in 1906 by wealthy landowner, Hugh Lock King, on his private estate in Weybridge when there were only 40 miles of tarmac road in the whole of the British Isles. In 1907 the engineer A.H.R. Fedden joined Straker-Squire Ltd and his designs ran well at hill climbs and at Brooklands. (*Sir Adrian Cadbury*)

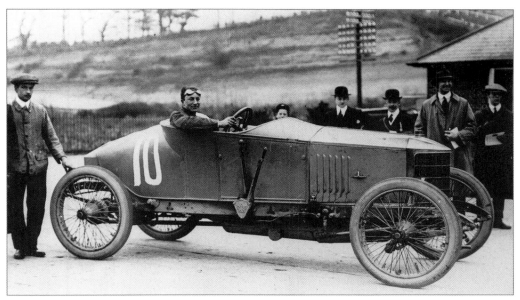

Above: Laurence J. Cadbury who won the Private Competitors' Handicap in his 20.1 hp Vauxhall Prince Henry (affectionately known by the family as 'Beetle') at the Brooklands Easter meeting in 1913. There were twelve entries, and the average speed of the winner over the 5.75-mile course was 67.5 mph. Mr Cadbury also came in fifth out of eighteen entrants in the 70-mph Short Handicap. In the *Bournville Works Magazine* of February 1964 a writer recalls, 'Mr Laurence Cadbury had a red racing car, which he used to race up the lanes of Bournville and Northfield at what seemed a very fast speed, but was probably only about twenty-five to thirty mph, causing the chickens to fly in the air as he raced by the farms. Local children found this great fun.' (*Sir Adrian Cadbury*)

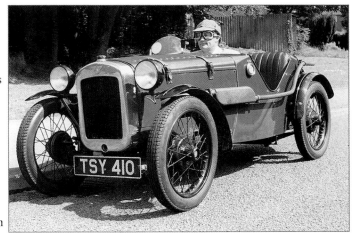

Having fallen into a state of disrepair the above Austin Seven 'Ulster' was reconstructed about 1996 using a variety of components with all the main mechanical parts having been made around 1930. In 2001 Malcolm McCoy bought the car and fitted a new body. In addition to participating in competitions such as hill climbs and sprints, he uses it every day for domestic use. The Austin Seven appeared on the market in 1923 as a two-to three-seater car costing £165. It was immediately decided to race the new vehicle and by 1928 the Austin Co. had introduced a proper sports model usually called the 'Ulster' costing £185. In 1930 an Austin Ulster won the BRDC 500-mile race at 83.42 mph. The Austin Seven was in production from 1923 until 1938, during which time some 400,000 were produced. (*J. Smith*)

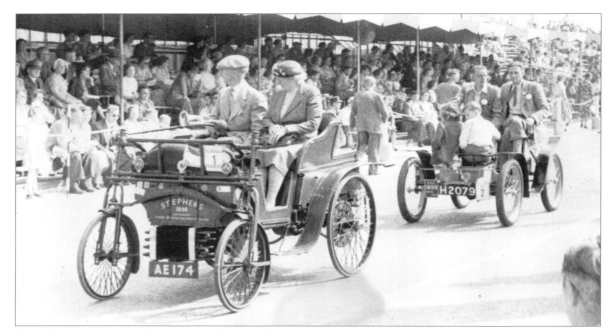

The 50th Anniversary Cavalcade of Vintage Cars at the Austin Motor Co., where very many people from Northfield worked, 1955. The procession took place on the field that had been used as a runway for testing fighter aeroplanes made at the factory during the Second World War. In 1991, on the fiftieth anniversary of the death of Lord Austin, members of the Austin Village Preservation Society joined up with the Austin Seven Club to make a pilgrimage to lay a wreath on the grave of Lord Austin in Lickey Church. (*G. Callow*)

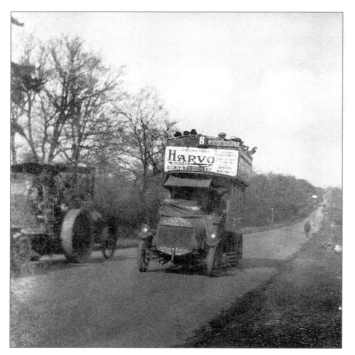

By the entrance to the Manor, a traction engine, and an early motor bus making its way to Northfield, pass on Bristol Road, *c.* 1923. (*W. Barrett*)

Opposite: Plan showing all the possible exciting uses of domestic electricity in 1926. The demonstration showed that, commencing from cold, a good bath could be obtained in two hours! Following the demonstration of uses for smaller types of house a similar exhibition was organised in a larger house in Innage Road, when at night the outside was illuminated by 'flood lights'. What the housewife really wanted to know was whether electricity would give an equal or better result for less cost in hard cash, or in considerably reduced labour. (*Cadbury Trebor Bassett*)

In February 1926 the *Bournville Works Magazine* reported on two houses which were built in Hole Lane using the 'all-electric' principle, when arguments for and against were vigorously expressed, especially among those who visited the houses during the demonstration week. The main arguments *against* coal by the advocates of electricity, were that it wasted heat, was bulky to store, dirty and heavy to handle. The coal fire made dirt and was unhygienic and wasteful of labour. It was felt necessary to conserve coal resources, to reduce smoke thrown into the atmosphere and to reduce the cost of building by eliminating coal stores, chimney-breasts and so forth. The case *for* coal was based on the traditional affection for a blazing fire, dislike of the quality of electric light and heat, and others held that it was not merely disagreeable but unhealthy! (*Cadbury Trebor Bassett*)

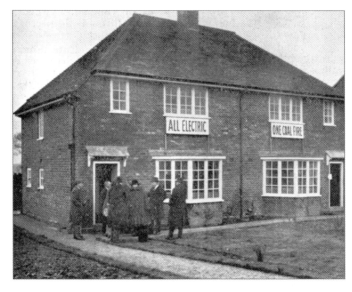

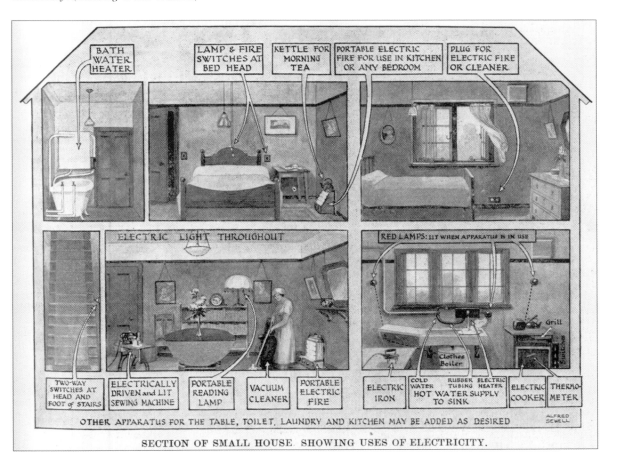

SECTION OF SMALL HOUSE SHOWING USES OF ELECTRICITY.

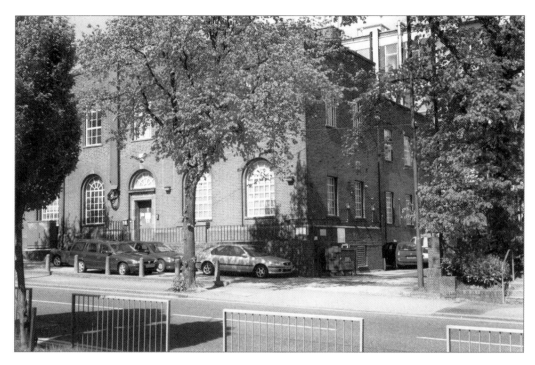

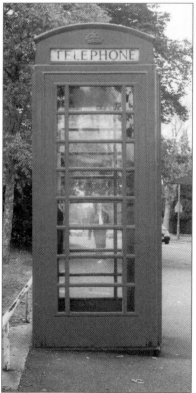

The Telephone Exchange on Church Hill, 2002. In the 1960s/70s a large extension was built at the rear of the original brick building, and towards the turn of the century, when mobile phones and the Internet began to gain popularity, many large aerials were constructed on top of this extension. (*J. Smith*)

Red phone box near the junction of Bunbury and Overbury Roads, May 2002. In 1884, eight years after Alexander Graham Bell invented the telephone, the British Postmaster-General allowed telephone companies to establish public call offices, or payphones as they later became known, giving access to all, not just the rich. Call offices were originally located in shops, but because of problems deriving from this, in 1906 payphones were put into free-standing kiosks. In 1924 Sir Giles Gilbert Scott, architect of Battersea Power Station, designed the prototype of the famous red phone box which he perfected in 1936 with the K6. Bell saw a future in which people would communicate around the globe, but could he have imagined today's multi-purpose public payphones? (*J. Smith*)

Coins & Cards phone box near the junction of Bristol and St Laurence Roads. Many kiosks were replaced in the 1980s with stainless-steel versions, in which coins or cards could be used, first in a stark, square shape but later modified to the rounded top which, it was felt, blended more sensitively and provided a more welcoming environment. However, public dismay led to the remaining red phone boxes being listed and about 15,000 remain today. About 33 per cent of faults are reported by the payphone itself, and £13 million a year is spent on cleaning costs. Today there are more than 133,000 payphones across the UK, and more than 2 million people use them every day. (*J. Smith*)

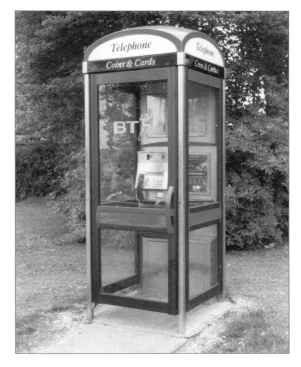

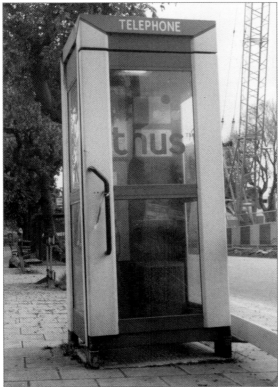

'Thus' phone box near the junction of Bristol Road South and Great Stone Roads. In July 2002 the *Birmingham Evening Mail* reported that the City is at the forefront of a revolution to turn the traditional phone box into the world's largest public network of Internet terminals. Fourteen of the new hi-tech kiosks will be installed in the City for the second phase of a public trial by BT. They will offer full pay-as-you-go Internet access, e-mail, text messaging and payphone calls. BT hopes 28,000 of the terminals will be installed across the country over the next five years, and exciting new multimedia terminals are already becoming a common sight in places such as shopping centres, railway and tube stations, service stations and airports throughout the UK. (*J. Smith*)

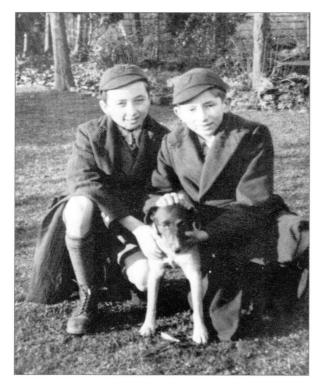

Denis G. (always known as Bob), (left) and Peter Ricketts together with their dog Fingle in the garden at Hollymoor Hospital, *c.* 1938. Peter trained in America as a pilot for the RAF during the Second World War. When demobbed he returned to journalism and became golf writer for the *Birmingham Post & Mail*. He retired as features editor of the *Birmingham Mail*, but has continued to write in his retirement. Bob joined the Austin Motor Company's Apprentice Scheme on leaving school, taking his Indentures at the Technical College in Suffolk Street. He moved on to other firms in the group, became a Senior Rate Fixer at SU Carburettors, an Industrial Relations Manager, finishing as Board Manufacturing Director with the GKN Group from where he retired. (*R. Ricketts*)

The Head Gardener's House in the grounds of Hollymoor Hospital where Peter and Bob were born. John Ricketts, their father, became head gardener at the Hollymoor Hospital site in the 1920s. It was a totally self-contained community and John was responsible for supervising and training patients to tend the flowerbeds, work in potting sheds and greenhouses, produce vegetables and generally keep the grounds clean and tidy. He retired from Hollymoor in the 1940s but continued to do some gardening in his spare time around the Norman and Woodland Roads area. (*R. Ricketts*)

2

Sports

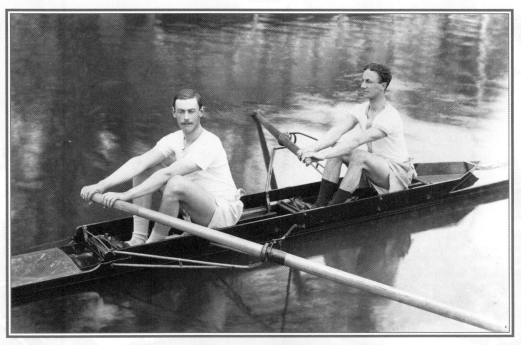

F.E. Hellyer and L.J. Cadbury, 1st Trinity, winners of the Magdalene Pairs in May 1911. Laurence J. Cadbury, who lived at The Davids in Hole Lane, Northfield, was a student at Cambridge University from 1908 to 1911. As a holiday jaunt in 1910, he and his brother, Henry Tyler Cadbury, rowed on canals and the rivers Severn and Thames from Tewkesbury to Putney. During this trip they passed through thirty-four locks, the charge for passing through each one being 3*d*. (*Sir Adrian Cadbury*)

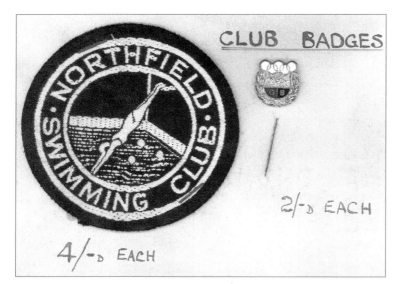

Northfield Swimming Club, with its distinctive badges, was founded as a ladies' club in 1939, and was one of the youngest clubs in Birmingham. Shortly after it began Northfield Baths were closed to swimmers and made into an ARP station for the duration of the war. The club resumed in 1946 and, after two unsuccessful attempts to form a men's club in the early postwar years, a men's section eventually joined the ladies in 1950, which formed the basis of the later mixed club. Success in the competitive field came almost immediately with a Warwickshire schoolgirl champion, followed by Ladies' SC County Champions. (*R.W. Jones*)

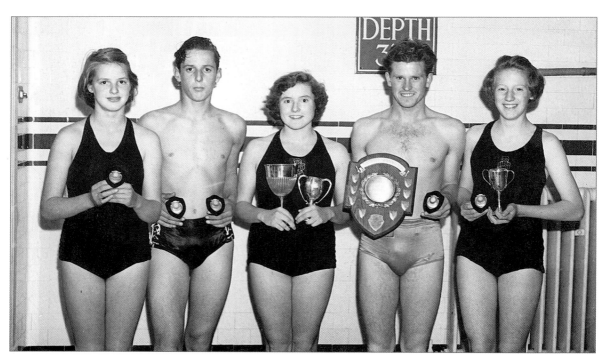

Members of Northfield Swimming Club proudly displaying their medals, cups and shield. The first men's success came in 1961, after which numerous Midland and Warwickshire titles were won. Although the competitive element was very strong and was the major factor in forming the excellent team spirit among members, the main emphasis was placed on teaching youngsters to swim correctly. Ability was the criterion the whole way through the club, and a simple test was taken by each swimmer to graduate from one group to the next. At its peak in the 1960s the club had an annual membership in excess of 350 with the second highest club weekly attendance in the city. All instruction given at Northfield SC was entirely voluntary. (*R.W. Jones*)

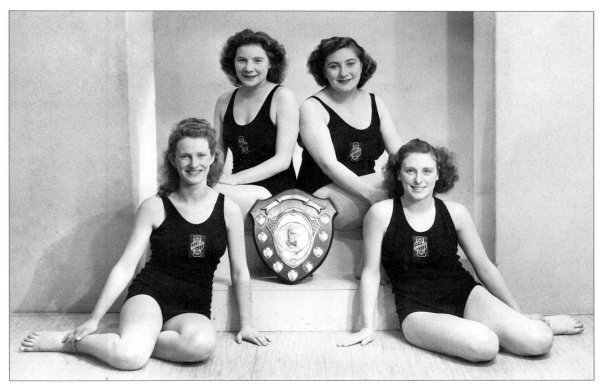

Girls from the Northfield Ladies' Swimming Club who won the Birmingham and District Swimming Association 2nd Division's shield in 1947. Left to right: Joy Payne (whose family ran a sweet, tobacconist and fancy cakes shop in Northfield), Betty Villes, Joan Finch, Pat Knight. (*J. Finch*)

Northfield Ladies' Swimming Club's Programme of Events at the Swimming Gala held at Northfield Baths on Saturday 28 September 1946. Admission was by programme only, price 1s 6d! In 1966 the *Bromsgrove Messenger* reported that 'application was made for a second night's use by the club but the City Baths Committee turned it down on the grounds that 80,000 people lived in the surrounding district and the pool should be available to the public for the maximum time. A reasonable argument but a somewhat negative one if the city was interested in the slogan "every child a swimmer!"' (*R.W. Jones*)

PROGRAMME OF EVENTS
IMPORTANT NOTICES

* The Starting End of the Bath must be kept clear.
* Competitors must report to the Starter immediately their Event is called—failing to do so may cause disqualification.
* Children making themselves a nuisance will be expelled from the Baths.
* Silence is requested at the Start of each Event.

1st. Event 7 p.m.
GIRLS UNDER 13—Free style—(one length)
1st 2nd 3rd Time

2nd. Event 7-8 p.m.
BEGINNERS (Juniors)—Width
1st 2nd 3rd Time

3rd. Event 7-16 p.m.
BREAST STROKE (Best Style)—(one length)
1st 2nd

4th. Event 7-26 p.m.
JUNIOR DIVING COMPETITION—2 Dives
1st 2nd

5th. Event 7-36 p.m.
OPEN CLUB CHAMPIONSHIP—100 yards
1st 2nd 3rd Time

6th Event 7-44 p.m.
GIRLS UNDER 16—Free Style—(two lengths)
1st 2nd 3rd Time

7th. Event 7-54 p.m.
NOVELTY RACE JUNIORS—Cork Bobbing
1st 2nd 3rd

8th. Event 8 p.m.
SENIOR HANDICAP—(two lengths)
1st 2nd 3rd Time

9th. Event 8-10 p.m.
CLUB DIVING CHAMPIONSHIP—3 Dives
1st 2nd

10th. Event 8-20 p.m.
SENIOR NOVELTY RACE
1st 2nd

11th. Event 8-30 p.m.
PRESIDENT'S REMARKS AND PRIZE GIVING
Mrs. COVENTRY

12th. Event 8-45 p.m.
INVITATION TEAM MEDLEY RACE—two lengths
(3 in each team)
South Birmingham Ladies
Sparkhill Ladies
Kings Heath Ladies
Central Ladies
Northfield Ladies

13th. Event 8-53 p.m.
DISPLAY CENTRAL LADIES

14th. Event 9 p.m.
SQUADRON RACE
Redditch v *Sparkhill*

15th. Event 9-15 p.m.
POLO MATCH
Redditch v *Sparkhill*

THE NORTHFIELD LADIES SWIMMING CLUB express their thanks to visiting Teams and Officials for their support.
NORTHFIELD LADIES SWIMMING CLUB continues through the Winter Season. Monday nights 7 till 8 p.m.
(Professional Instructress—Mrs. JORDAN
New Members welcomed
Contact Secretary Monday evenings
NOTE.—Club Colours—Black Costumes and Green Caps

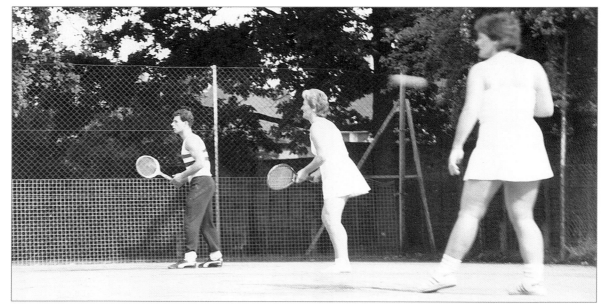

Woodlands (Northfield) Lawn Tennis Club, founded in 1926 when the Bournville Village Trust laid out an amenity area between Bunbury and Innage Roads, contained two shale courts and a wooden clubhouse. Except for the war years, the club functioned with a membership from local families playing purely social tennis. It became more competitive when the Dixon and Taylor families moved into Northfield in the mid-sixties, Mary and Zoë proved to be a famous ladies' doubles' partnership, and won fourteen consecutive titles in the Senior Doubles' Knockout Competitions. At the same time they both spearheaded successful ladies' teams in the Warwickshire LTA's Birmingham Area Leagues. In the Leagues' Team competitions the club has won both the Senior Cup and the Mixed Shield, and during the 1970s and early 1980s it hosted the finals of the Knockout Competitions. Membership consists of seniors and juniors and a coaching week takes place each year at the end of July. Seen here in about 1983 are Philip Dixon, Mary Dixon and Carol Turner. (*B. Turner*)

However, despite the pleasant situation and old-world charm, the courts proved susceptible to very wet weather, which quickly rendered them unplayable, and by the mid-1990s it became clear that the club would not continue unless major improvements were made. With generous donations from members, local residents and Bournville Village Trust, new all-weather courts were laid and officially opened in March 2000. A grant from the Sports and Arts Council enabled the clubhouse to be refurbished in 2001, and a number of social and fund-raising activities take place during the year. Today the tennis club is thriving and with these new facilities should be able to continue for many years. (*M. Dixon*)

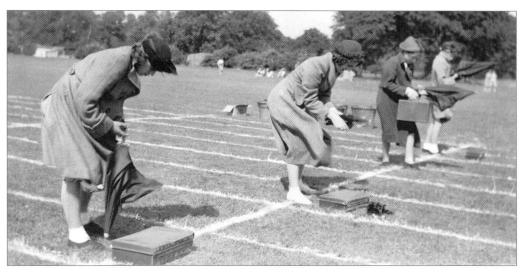

Tinker's Farm Senior Girls' School's Sports Day, 24 July 1951: Catch the Train race. Sports days were always very popular, the races including not only track events, but also skipping races, three-legged races and potato races. Sporting competitions were always held between the various Houses. The original Girls' Houses were Torchbearers, Resolutes, Invincibles and Pioneers, while the Boys' were Normans, Danes, Saxons and Britons. Following the two schools merging the Houses were renamed Avon, Severn and Trent. (*N. Bartlam*)

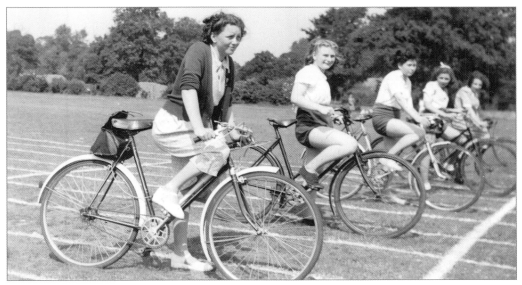

The Slow Bicycle race, so named as the last one to cross the line was the winner, 24 July 1951. The most athletic pupils represented their school in various sporting competitions such as the King's Norton District Sports and the All Birmingham Sports. Len Day, who gained the first medal ever won by a Tinker's Farm pupil, won it at the King's Norton and District Sports in 1932. He recalls it being presented to him by Miss Walmesley, the headmistress, in front of the whole school – making him feel as proud as if he had won a Gold Medal at the Olympic Games. (*N. Bartlam*)

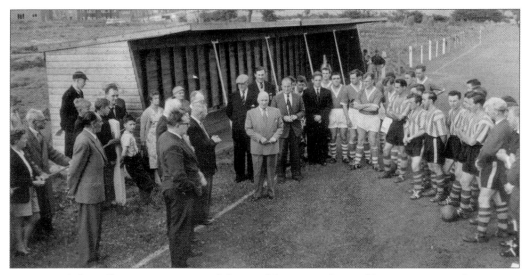

Opening of the Allens Cross Sports Club stand by Mr Jack Mould OBE, 6 September 1958. When first opened in Shenley Lane in 1935 the Allens Cross Sports Ground was on a narrow tree-lined country lane, which was replaced in 1967 by the modern dual carriageway. Initially a tea-room provided refreshment, but in the late 1960s a bar was installed. Over the years the club has seen many improvements in facilities, partly from its own efforts and partly with the aid of grants from various charities, and many future projects are planned. It is now a thriving community and social centre with a large membership and is used by a wide variety of groups. (*M. Davis*)

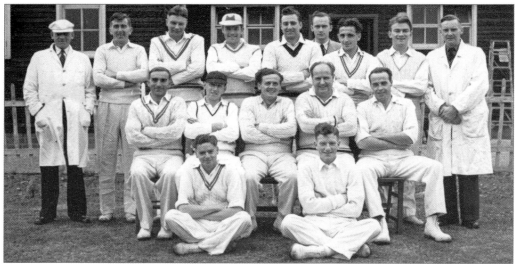

Allens Cross Cricket Club, on their home ground in front of the clubhouse, 1956/57. Following the opening the ground was a great success and became home to the football and cricket sides both playing under the name of Allens Cross. Until the early 1970s, when the court fell into disrepair, a tennis section was very active. A table tennis section was also popular. The ground was initially used for other sports and a grand Annual Sports Gala was inaugurated in 1938. During the war years baseball became popular and this continued into the 1950s. (*M. Davis*)

Northcross Boys' Club's under-thirteen football team after a winning cup final, 1960/61. In 1956 Northcross Boys' Club moved to Allens Cross Community Hall in Tinker's Farm Road. Its sports sections excelled in all areas. The club was a strong competitor not only in soccer and cricket but also in darts, table tennis and swimming. Apart from very good relations with local clubs, the club forged links with Pontypridd Boys' Club. The two sides met every year for football matches and social events, alternating between Northfield and South Wales. (*A. Pickering*)

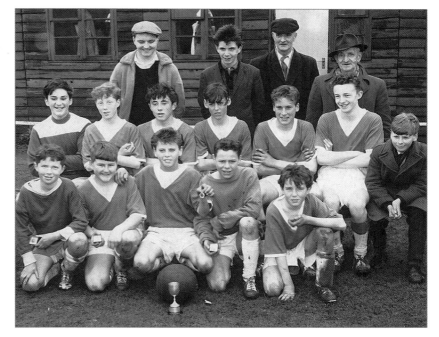

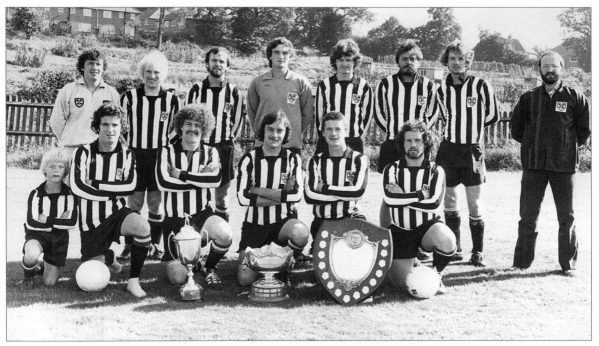

Northcross Boys' Club's 1st XI football team, which won all the major trophies in the Kings Norton League, 1978. The photograph was taken at their Colworth Road ground; the houses which can be seen at the back left are in Crossland Road. Alan Pickering was the General Manager of Northcross with overall responsibility for three football teams, and Colin Lowe was Team Manager. At the extreme left of the front row is Christopher Lowe, Colin's son, who was the team's mascot. (*A. Pickering*)

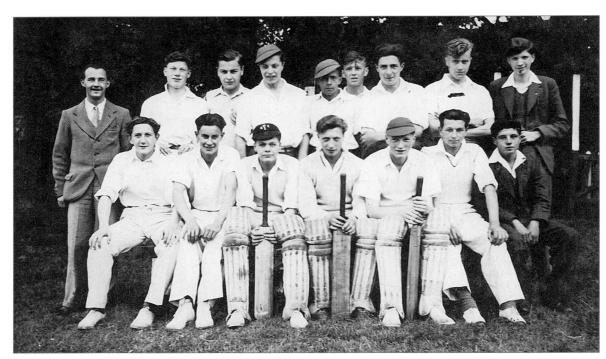

Northfield Institute Cricket Team on their playing field, which had cricket and football pitches, and was where St Laurence C/E Junior School and its playing field now stands, *c.* 1948. Front row, left to right: Raymond Forrester, Dickie Hall, Johnny Heath, Wilf Coffman (became Football League linesman and referee), Frank Mumbey, Eddie Sale, Norman Guy. Back Row: -?- , -?- , ? Heeley, Brian Furniss/Furnace, ? Heeley, Bobby Whiting, Keith Grubb, Brian Baker, Keith Harwood. (*D. Taylor*)

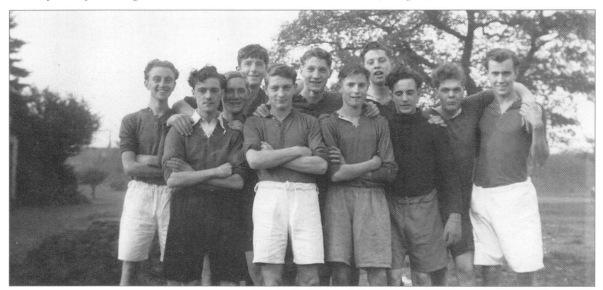

Northfield Institute Football Team on Victoria Common, October 1948. Left to right: -?-, Neville Hopwood, Evan Pring, Brian Baker, Leonard Mumby, Frank Mumby, Leonard Gould, Bobby Whiting, Alan Rock, Johnny Heath, David Taylor. (*D. Taylor*)

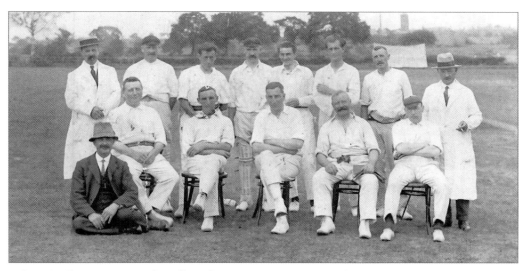

Rubery/Hollymoor Hospital Staff Cricket Team, *c.* 1930. Mr John Holyoake Ricketts (in whites, seated second from left), Head Gardener at Hollymoor, was very proud of the fact that in his younger days he once played cricket against W.G. Grace. (*R. Ricketts*)

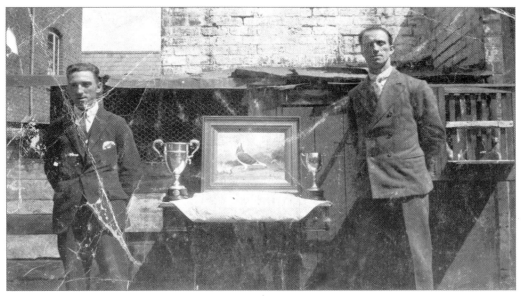

Rhoda's father, Harry Niblett, with his brother Alfred (known as Mick) at the yard in Ladywood where they bred and kept pigeons, standing proudly beside a photograph of Flash, together with the cups she won in races. Flash, a black Cheq Pied Hen, came third in the Ventnor, fourth in the Lymington and Pools and first in the 400-mile race from Nantes to Birmingham in 1925, being the only bird home on the day. She was bred by her owners, Messrs Niblo Bros, members of the St George's Homing Society, Birmingham. Rhoda recalls her father, Harry, cycling back to Northfield with the pigeons in a basket. On his arrival home he released them to fly back to Ladywood as training for their homing instincts. At the beginning of the racing season, which runs from April until September, the races are no more than 60 miles, but by the end of the season can be ten times that distance. (*R. Ricketts*)

A fishing contest for members of the Bournville Works Men's Fishing Section held at the Manor Pool on 23 August 1913. One hundred and five members took part and 78 caught fish. Over 500 fish were taken from the water. Eleven prizes were awarded and George and Elizabeth Cadbury provided tea for the members. The Ladies' Section (with fierce competition for places) also held contests there and a more delightful spot than that by the weir could not be desired, with its thickly wooded rough carpet of tangled undergrowth, while the steady rippling of the water over an artificial cascade provided an unbroken and harmonious accompaniment. (*Cadbury Trebor Bassett*)

On the left Victoria Lees and two other girls are seen participating in the Egg and Spoon Race at St Laurence Junior School Sports Day, 15 July 1988. (*S. Lees*)

3

Leisure

A seventeenth-century poet described prayer as 'church bells heard beyond the stars'. The newly installed ring of ten bells in St Laurence Church tower in 1999, taken with a special fish-eye lens. An interesting photograph, which, through distortion, shows the complete ring with Bob Lewis standing to the right of the new treble bell. Documents tell us that in 1552 there were three bells in the tower. Two more had been added before 1730, which may have been in 1637 when the existing wooden frame was made. In 1730 Joseph Smith of Edgbaston recast the bells and made them into six, which were in use for almost 200 years. They were again recast in October 1923 by Taylors of Loughborough but were not installed until the latter half of 1924 because of the need to modify the old frame to accept them. It seems fairly certain that the bells were exhibited at the Great Empire Exhibition at Wembley and that Taylors were awarded a medal for the excellence of their work. (*R. Lawson*)

Bells, in the 'up' position, in the wooden bell frame, prior to removal in 1999. They had not been easy to ring in recent years as the old wooden frame, due to decay of the timbers, was showing considerable signs of movement. A project to hang the bells in a new frame and augment them to ten was originally conceived in 1992 when a structural report was prepared on the tower and bell frame. The art of change-ringing was introduced by Fabian Stedman, a Cambridge printer, in 1657. Before that bells were rung in more or less haphazard fashion, but Stedman discovered that by means of rearranging the order of pealing at every round, a set of seven bells could produce 5,040 non-repeating changes. Such a 'ring' lasts about four hours. As the number of bells increases, so does the number of changes. (*M. Edwards*)

Eight old bells on the lorry ready for transportation to the foundry. It took six years of hard work by the Rector, the Revd Robert Warren, the PCC and the fabric committee to obtain a faculty to augment the existing 'classic' 1923 Taylor eight to ten bells and hang them in a new steel frame below the original 1637 wooden frame. In 1997 the diocese decided to grant the faculty on condition that the existing frame remained in its original position. This meant that the new bell frame was placed at the then ringing chamber level and the bells were henceforth to be rung from the ground floor.
(*M. Edwards*)

Casting the treble bell at Loughborough, 4 March 1999. It transpired that a considerable amount of extra work would be required on the tower, some caused by the lowering of the ringing chamber, but also work necessitated by deterioration of the tower. In addition to other things this consisted of re-flooring the ground floor in York stone, moving the font, removing the old organ loft, panelling the west side of the tower in light oak and accommodating the clock, complete with delightfully restored face, in its new position. In addition some acoustical work, both internal and external, has been necessary partly due to the re-siting of the bells lower in the tower. Before foundries were established, church bells in need of repair were attended to by travelling tinkers who set up their equipment in the churchyard and stayed in the neighbourhood until their work was done. However, this sometimes caused problems as occasionally a bell disappeared with a tinker! (*M. Edwards*)

Northfield, St Laurence band of ringers with the Rector, the Revd Robert Warren, Churchwardens and Bishop taken on dedication day. The local ringers had an enjoyable test ring and found that the two new trebles were a perfect blend to the ring, and the go and handling of the bells was perfectly satisfactory. After a little acoustical work was done to lower the sound level internally and raise it externally the bells were dedicated on 24 June 1999. (*R. Lawson*)

L.J. Cadbury of The Davids, Northfield, with a petrol engine he built in his schooldays. The petrol engine, with both bore and stroke of 1½ inches, was built when motor cars were still rather a novelty, and the square engine had yet to become popular. He made the original drawing at school and from this produced wooden patterns during his holidays. Castings were made from these patterns, which he then machined and assembled in the school workshop. Many of the parts were made in aluminium, long before this metal became widely used. Mr Cadbury is seen here demonstrating an ingenious starting device he fitted, replacing the usual pulley and leather belt frequently used for starting diesel engines in model high-speed boats. (*Cadbury Trebor Bassett*)

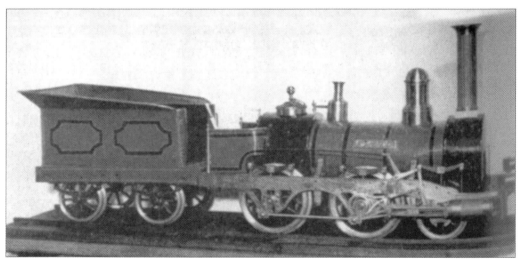

Model of a broad-gauge locomotive, *Plato*, built at Plymouth in 1840 in the heyday of Brunel's Great Western Railway, from L.J. Cadbury's collection. It was constructed to demonstrate a particular system of braking, and is all the more remarkable when one considers the limited range of machine tools available to its builder. (*Cadbury Trebor Bassett*)

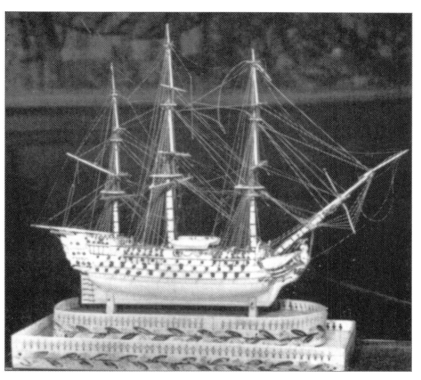

This illustration, together with the one below, is a fine example of a model warship, which, in 1961, was part of a collection of ten owned by L.J. Cadbury, who was extremely interested in military history. French prisoners constructed these models during the Napoleonic Wars. They appear to be of ivory but are, in fact, constructed from thin sections of bone (from prisoners' rations) pinned on wooden hulls. The makers were generally conscripted ivory carvers, and they relied for the accuracy of their models on the advice of long-term seamen of the French navy. (*Cadbury Trebor Bassett*)

Venerable – a warship of 1,659 tons launched in 1784 with a complement of seventy-four guns and a crew of 600. She was Admiral Duncan's flagship at the battle against the Dutch at Camperdown in 1797 and was under the command of Captain Hood at Algeciras Bay in 1801. *Venerable* was finally wrecked in Tor Bay in 1804. In addition to making models, Mr Cadbury also built up a fascinating collection of models of locomotives and hot air, petrol and steam engines which he purchased, and which were examples of early efforts in the field of model making. (*Cadbury Trebor Bassett*)

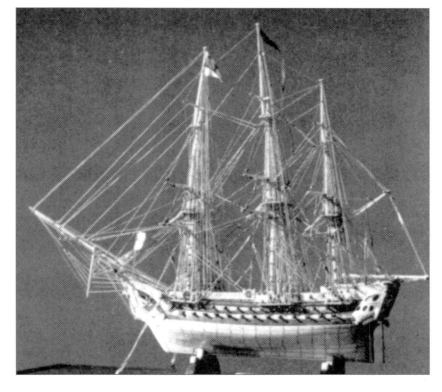

A ceremony with the Lord Mayor, Ald. J.R. Balmer and the Lady Mayoress to help the UNICEF appeal, 18 May 1955. Tinker's Farm Senior Girls' School was represented by Diane Merryweather (May Queen), Jacqueline Joy (Herald) and Dawn Stewardson (Crown Page). Miss H.R. Walmesley, the first headmistress of the Girls' School, was a member of the League of Nations and travelled widely striving for two things – Peace and Education. The United Nations International Children's Emergency Fund was, at this time, the only section of UNA for which funds were raised entirely on a voluntary basis and campaigns for support were held in many parts of the world. Most of the funds were devoted to the prevention and cure of childhood diseases, a portion going to the building up of essential food stocks which could be rushed to stricken areas where flood, drought, earthquake or war left famine behind. (*N. Bartlam*)

Diane Merryweather (later Diane Welch) at her crowning as twenty-first May Queen, at Tinker's Farm Senior Girls' School May Festival on 23 May 1955. (*J. Welch*)

Harvest Festival, October 1960. House Captains from Tinker's Farm Senior Girls' School present contributions for the 'old people of Northfield' to a representative from the *Birmingham Post & Mail*. (*N. Bartlam*)

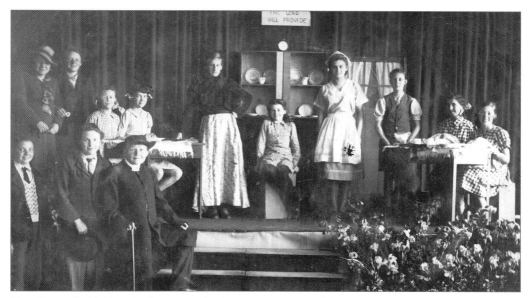

May Festival, 1943 – A class at Tinker's Farm Senior Girls' School performing *Daddy Longlegs* in which Rhoda Ricketts (née Niblett) played Judy, Mavis Buggins was the Matron and Violet Drinkwater Daddy Longlegs. For the annual May Festival a coronation ceremony was first performed before the whole school. The retiring queen gave a farewell speech, which was followed by the abdication ceremony. The herald announced the election of her successor, and, to the singing of 'Come Lovely Queen', the procession re-entered and the new queen was crowned. The whole school, accompanied by the choir, then sang 'The May Queen's Song'. (*R. Ricketts*)

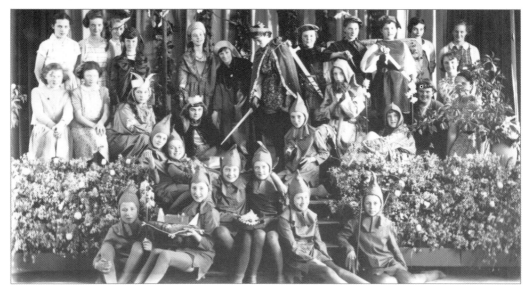

May Festival, 1956. Miss Chesterton's Form 4 performs 'The Imp Tree', for which they received special praise for the quality of the costumes. Following the coronation ceremony each class performed a play or activity such as choral speech, mime, singing and dance, and there was a great feeling of festivity. (*N. Bartlam*)

St Laurence Youth Fellowship reunion. In April 1992 former members of the St Laurence Youth Fellowship came from as far away as Canada and America – as well as from all over Britain – for a grand reunion. Up to 100 former members who attended the club between 1945 and 1953 were present at the special meeting, which was held at the Pastoral Centre. Further reunions were held in 1994 – 50th Anniversary Celebrations at the Pastoral Centre, and 1997 – reunion at the Black Horse. (*M. Rock*)

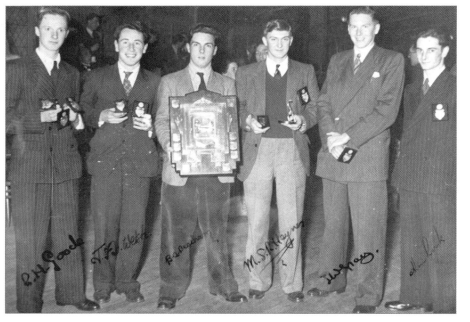

St Laurence Youth Fellowship table tennis team, 1949/50. One of the many sporting activities of the Fellowship was an excellent table tennis team. Members seen here are from left to right: Charles Goode, Johnnie Welsh, Barry Beacham, Mike Heynes, Trevor Gray and Alan Rock. (*M. Rock*)

A group of Youth Fellowship members and friends from Kings Norton Grammar School at their fête, August 1948. The photograph includes three German girls who were here on a short visit at the invitation of Kings Norton Grammar School and who stayed with pupils in their homes. In addition to all the local activities Fellowship members also took part in summer camps and trips abroad. (*M. Rock*)

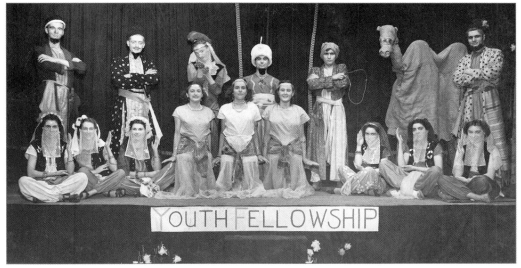

'In a Persian Market', performed as part of a concert by members of St Laurence Youth Fellowship, March 1948. Because of the scarcity of all commodities following the war years, scenery had to be devised from practically non-existent material, and even such common things as curtain hooks were difficult to obtain. All the scenery was designed and painted by members of the Guild and it was not easy to find the best times for rehearsals as many of the cast were at night school or working, but despite these difficulties the concert was a great success. (*M. Rock*)

Allens Cross Community Players. *Without the Prince* was produced in about 1950 by Wilf Boyer. Players from left to right: Pat Thomas, Elsie Philips, Don Bierman, Ivy Ganner with Dorothy Winfield seated. Allens Cross Community Players were formed in about 1948, met for rehearsal in the Hut at Allens Farm Community Hall, and were noted for their excellent teamwork. Wilf Bowyer was the originator of the group and Gren Davies the director. (*G. Davies*)

A scene from *Wild Goose Chase*, produced by Gren Davies, *c*. 1958. Cast, left to right: Fred Eysenck, Gren Davies, Eric Banks, Don Bierman, Joan Eysenck, -?- , Ruth Watts. The group, which consisted of approximately nine members, made all their own scenery on Sunday mornings. (*G. Davies*)

Someone Else's Pretty Toys, produced by Gren Davies, *c.* 1960. Cast, left to right: Sheila Neish, Jean Shelley, Ruth Watts, Gill Salkeld (née Whittaker), -?-, Freda Grew, Gill Wilkes. The group performed three plays per year and, owing to enthusiastic support from a large number of devoted fans, productions were always sold out. (*G. Davies*)

Award being presented to Gren Davies in February 1961 by Bernard Hepton (Adjudicator) and Beryl Foyle for his production of *Save the Standard*. The play by Victor Lewis received high commendation and won first place in Birmingham and second place in Hereford Midland Divisional Finals for Allens Cross Community Players. This qualified them to appear in the British Drama League's Western Area Final in May that year, where Cecil Bellamy (Adjudicator) was 'much impressed' by their performance. (*Birmingham Post & Mail*)

St Laurence C/E School Parent-Teacher Association's production of *Cinderella*, January 1951. Joyce Priestnall is the reader with Susan Denning, Clifford Price and David Chinn listening. Originally intended to play for two nights *Cinderella* was so successful, and so great was the demand for tickets it was presented on four nights. It was seen by around 1,300 people, including Dame Elizabeth Cadbury, with many others being refused. The cast was largely composed of mothers of children at the school with the book, which was entirely in rhyme, being written by one of their number, Winifred Chinn, who at short notice had to give up the job of producer to play the leading role. The production was taken over by her husband, who happened to be home from America at the time. Mr Chinn's production was a slick and fast-moving one, and Nancy Cull's excellent choice of songs fitted exactly with each scene as it was performed. (*J. Upton*)

St Laurence C/E School Parent-Teacher Association's production of *Babes in the Wood*, January 1952, with Robin Hood (Winifred Chinn) and Maid Marion (Elizabeth Hughes). The costumes for these productions were the result of an appeal for old black-out material and other odds and ends and were designed and produced by Mabel Hopkins and Eileen Tann. William H. Cross and S.G. Denning made the scenery, one of the notable features of the productions, and William and Alan Needle looked after the lighting and effects. Nancy Cull was chorus mistress as well as being responsible for all the music and Margery Mills was the pianist. (*J. Upton*)

Tim Hargest's class outside St Laurence C/E Old School, dressed ready for the annual end of summer term production, *c.* 1966. These displays, where every child in every class took part, were produced for the entertainment of the parents. (*D. Hargest*)

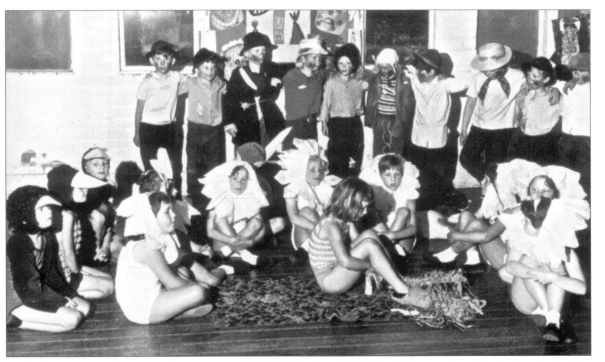

Tim's class in a production at St Laurence C/E Old School, *c.* 1967. Each class produced a display devised by their teacher using a theme consisting of poems, songs, dance and movement. (*D. Hargest*)

A group of contestants, all from the Northfield area, participating in Northfield Music Festival (as it was originally known), *c.* 1952. Back row: left to right, third Wendy Smith, fifth Elizabeth Dale. Middle row: Josephine Charlton, Janet Barnes, Ingrid Arnold, -?-, -?-, Mary Rossiter, -?-. Front row: Mavis Strugnell, Sylvia ?, -?-, Wendy Morgan (née Smith), -?-, -?-. From small beginnings Northfield Festival of Music and Spoken Word (as it later became known) at its peak grew to accommodate annually over a thousand entrants. Competitors have been drawn from as far afield as the Channel Islands, and are adjudicated by top professionals, many of whom constantly praise the overall high standard of performance. Winners of each class receive monetary awards, cups or shields. (*W. Morgan*)

Voluntary helpers Maud Dingley, Connie Whitehead, Andrew Smith and Mary Dale in the Committee Room at Northfield Festival of Music and Speech (as it had now been renamed), 1991. Mabel (usually known as Mary) Dale was a highly respected piano teacher in the Northfield area. As a founder member she was actively involved with the Festival up until her death in 1996 aged eighty-six years. For many years Mary coped admirably with an artificial leg, and one of her amusing tales was how, at one of the Festivals, the leg developed a loud and persistent squeak which accompanied her 'unmusically' wherever she went, until she hastened to a local cycle shop and had it oiled. At future Festivals she was constantly teased by friends wanting to know if she had come 'well-oiled'! (*P. Hobson*)

The interior of Northfield Methodist Church, which was built, mainly funded by war damage compensation, on the corner of Chatham Road and Bristol Road. Some people said the post-war church was too large, too high and too much like a cathedral, but extra chairs had to be rushed in for Sunday morning services for several months following its opening in October 1956, and for many more years it was crowded. The church has always been concerned for the surrounding community and over the years has provided many facilities such as a Luncheon Club for Senior Citizens, a Mother and Toddler Group, Play Groups, Summer Holiday Schemes, and Christmas shopping expeditions for the housebound and handicapped. (*C. Marlow*)

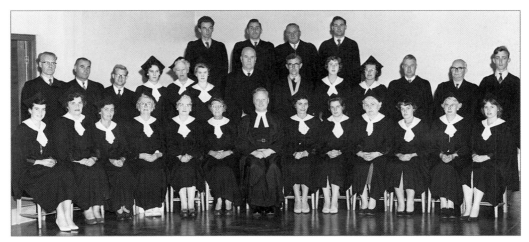

Northfield Methodist Church Choir, *c.* 1960. Middle row: centre with glasses, Eric Smith (a well-known local musician), on his left Christine Marlow (née Stafford), on the extreme right Paul Smith (Eric's son). Front row: centre, the Revd C. Banks, on his left Hazel Smith (Paul's wife) and fourth from left Edith Southerton. Many musical events, exciting concerts and dramatic productions took place at the Methodist church, a member of the drama group being Ian Lavender, whose father, the local police sergeant, was props steward. (*C. Marlow*)

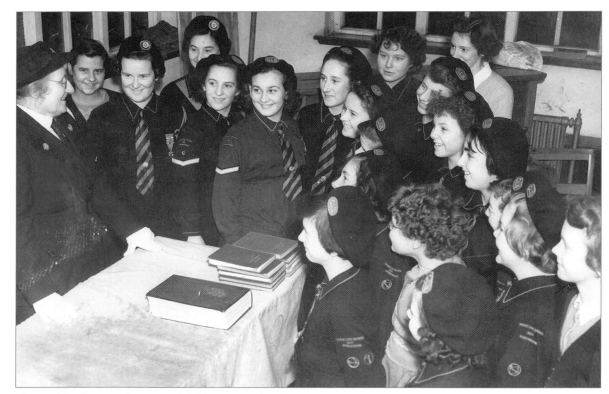

The Girls' Life Brigade at Northfield Baptist Church, 1955. The group includes Mrs Rose Dunkley (Captain), Eileen Gilders (née Dunkley), Margaret Bearman (née Lane), Josie Cardall (née Moore), Stella Wilson (née Jones), Anne Edwards (née Stokes), Yvonne Yearsley, Betty Hayward, Pat Pickering, Jackie Powell and May Lloyd (née James). The Girls' Life Brigade, which in 1965 changed its name to the Girls' Brigade, is the oldest uniformed organisation of its type in Britain. It began in 1893 and the first Birmingham company was formed in 1905. All groups are attached to a church with activities coming under four main headings – spiritual, physical, educational and service, with the Duke of Edinburgh's Award scheme playing a very big part in its activities. (*J. Cardall*)

The 206th St Laurence Masvil Cub Pack in St Laurence Infant School Hall at the Investiture of Amit and Arun Bahri, Mark Evans, Nicholas Prior and James Taylor, *c.* 1985. Akela is John Parry. There were two St Laurence Cub Packs, Concorde being the other. (*A. Evans*)

3rd Birmingham/1st Longbridge Guide Company meeting in the Hut (now the Annexe) at Northfield Institute, 1987. Claire Evans (third from right on the front row and the daughter of Brown Owl – Ann) is sitting in front of Kathryn Catty, Guide Captain. (*A. Evans*)

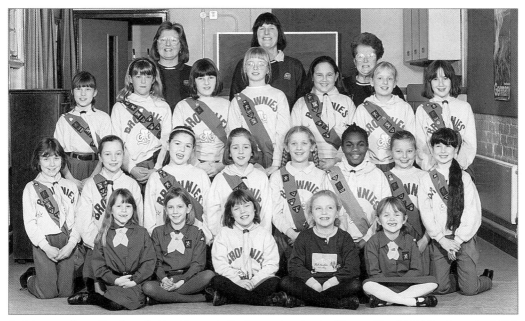

3rd Birmingham/1st Longbridge Brownie Pack meeting in the Hut at Northfield Institute in 1993 showing both their old and new uniforms. The adult on the left is Ann Evans (Brown Owl), who was a Warranted Leader with the pack for almost ten years finishing in 1995, in the centre Anne Stretton (Tawny Owl) and on the right Pam Hesmondhalgh (Snowy Owl). (*A. Evans*)

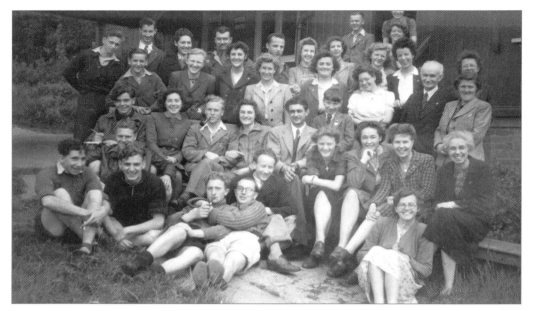

Esperanto class at Allens Cross Community Centre. Esperanto, devised by Dr Zamenhof in Poland and first published in 1887, is an international language and common tongue for world use. Easy to learn and easy to speak it is a way of talking across national barriers and of gaining a wider view of the world. Esperanto is based on the simplification of numerous languages, its grammar consisting of only sixteen rules with no exceptions, while the key words are selected mainly from the most widely known words in European languages. Also taught locally at Tinker's Farm Schools in the 1940s and 1950s, its popularity has now waned. (*C. Read*)

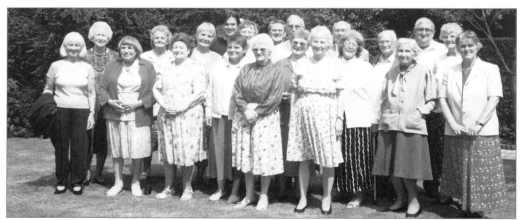

Members of Northfield Leisure Singers in the garden of Sheila and Brian Lees' house in Innage Road at the retirement of their Musical Director, June 2001. Northfield Leisure Singers was a mixed choir, begun in 1994 by co-author Jean Smith (née Whitehead), under the auspices of Northfield Adult Education Centre. With Jean as Musical Director, and Simon Larner as Accompanist, the choir met once a week for rehearsals at Northfield Institute. During its lifetime the choir gave many concerts at clubs, residential and nursing homes, pensioners' gatherings, and church organisations. It also helped in several fund-raising events for St Mary's Hospice. (*B. Lees*)

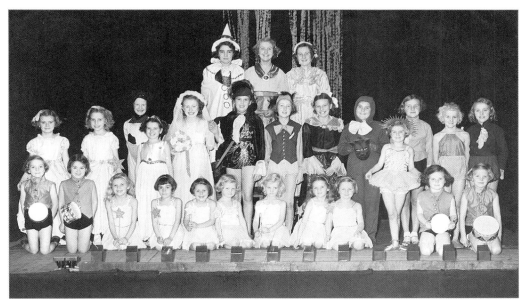

Cinderella, c. 1950. Mrs Edith Southerton, who lived in Nigel Avenue and was a member of the Methodist Church choir, produced concerts for the children in the Whitehill Lane locality during the 1940s/50s. Christine Marlow remembers virtually all the children in the area participating in some excellent productions, rehearsals for which took place in Allens Cross Sports Hall. In the centre can be seen Cinderella (Valerie ?), Prince Charming (Margaret Burke) and Dandini (Christine Marlow (née Stafford)). (*C. Marlow*)

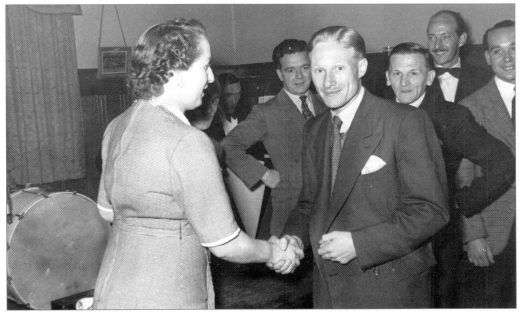

The manageress of the Beeches pub, Mrs Nash, presenting football medals in 1947. At this time most of the local pubs had their own football teams, the one at the Beeches being known as the Buffaloes. (*C. Read*)

Mrs Elsie Jones in the kitchen at Allens Cross Community Hall in Tinker's Farm Road, 1960. During the early 1950s a stalwart of Northcross Youth Club emerged – Mrs Elsie Jones – who came to the club twice a week on a voluntary basis to serve the boys with tea and cakes she had made, and to collect the subscriptions. Woe betide any boy who tried to dodge the weekly contribution! However, it was with the swimming that Elsie excelled. She became secretary of both Northcross and Northfield Swimming Clubs at the same time, as well as being county judge and timekeeper. She also ran the Federation of Boys' Clubs' Swimming Galas for the whole of the city. She retired from the Swimming Club in about 1984. Her son, Bob, was a founder member of Northcross and for many years Treasurer. The Club eventually closed during the 1990s. (*J. Walters*)

Deep in concentration over a game of draughts at Northcross Boys' Club, 1962. The club (renamed after its move to Vineyard Road) was a thriving place where boys could meet to play games, learn crafts, train in the gym and generally socialise and learn to become better citizens. (*J. Walters*)

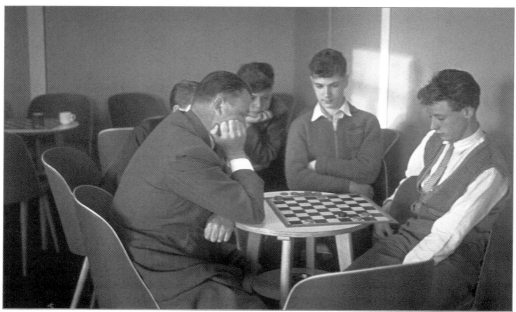

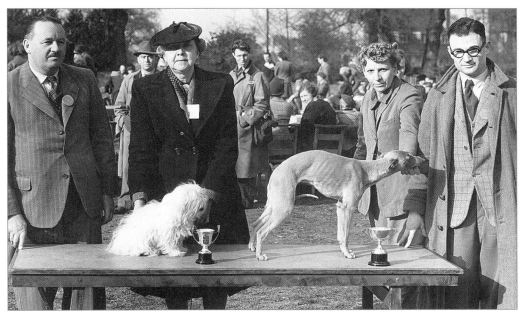

Northfield and North Worcestershire Dog Club Show, 1949. Extreme left: the Judge, Gerald Davis of the drapery shop in Bristol Road (see p. 28). Next to him is Maggie May Randle with the Maltese. John Clay's mother, Miriam, is in the centre on the Secretary's chair, with John wearing a beret sitting alongside. John's grandmother, Maggie May Randle, was a famous breeder of high class Pomeranians. Her animals received worldwide fame and four were sold and exported to the Maharajah of Jodphur while another became international champion in four countries. A qualified Member of the Canine Nurses' Institute, she was also one of the founder members of the Northfield and North Worcestershire Canine Society (registered with the Kennel Club in 1946), whose first shows were held in the wooden hut belonging to St Laurence Church. (*J. Clay*)

John Clay judging at Crufts in March 2003 with his Best of Breed Irish Wolfhound Champion Culkeeran Seth owned by Mrs and Miss D. Sexton. Three generations of John's family have judged at Crufts. His maternal grandfather, Albert John Randle, who was a Championship dog judge in the 1930s and 1940s, judged Pomeranians in 1937 at Earls Court, his father judged Lowchens in 1991 and John judged Irish Wolfhounds in 2003 becoming, it is believed, only the second person to have three generations of the same family judging at Crufts in its 100-year history. (*A.V. Walker*)

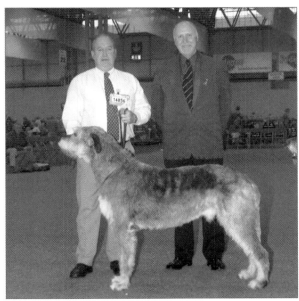

During the Revd E.A. Penny's years as Headmaster of St Laurence C/E Schools a very active drama group, linked with the Schools' PTA, performed shows in the old church hall known as the Hut. Among the group seen here, in about 1958, performing a farce are, third and fourth from left the Revd Penny and Joan his wife, and two along from her, John Andrews who was a teacher at the school. The Revd Penny was also conductor of Northfield Choral Society, which rehearsed at Northfield Institute, and performed works such as Bach's *St John Passion* and Verdi's *Requiem*. His daughter, Ceinwen, sometime leader of the Midland Youth Orchestra, was the accompanist. (*J. Andrews*)

Members of the 35th Girls' Brigade and 51st Boys' Brigade Bands from Northfield Baptist Church at Northfield Carnival in 1987. (*G. Harper*)

4

People

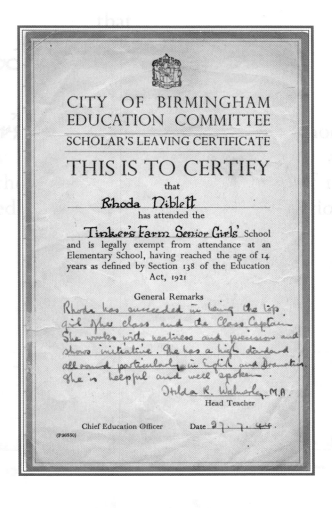

A Leaver's Certificate presented to Rhoda Ricketts (née Niblett) when she left Tinker's Farm Senior Girls' School in 1944. (*R. Ricketts*)

CITY OF BIRMINGHAM
EDUCATION COMMITTEE
SCHOLAR'S LEAVING CERTIFICATE

THIS IS TO CERTIFY

that

Rhoda Niblett

has attended the

Tinker's Farm Senior Girls' School
and is legally exempt from attendance at an Elementary School, having reached the age of 14 years as defined by Section 138 of the Education Act, 1921

General Remarks

Rhoda has succeeded in being the top girl of her class and the Class Captain. She works with neatness and precision and shows initiative. She has a high standard all round particularly in English and Dramatics. She is helpful and well spoken.

Hilda R. Walmsley, M.A.
Head Teacher

Chief Education Officer Date 27.7.44.

(P36550)

The Revd J. Crowle-Ellis, Rector of St Laurence Church from 1945 to 1956. He gained a degree at Oxford at twenty and in 1914 became a private soldier who rubbed shoulders with, and understood, the suffering, comradeship, danger and terror of ordinary men in war, the pain of separation from loved ones and the joy of being alive when it was all over. Much loved and highly respected, he was described by parishioners as 'A man who took you up to Heaven but kept your feet firmly on the earth'. At his funeral service it was said that few men showed the soul of goodness throughout all their work in the way that John Crowle-Ellis did, and, that during his term of office as Rector, Northfield had been blessed with something very rare and special. One pupil recorded that 'He not merely taught us History but stimulated us to form ideas and showed us how to express them'. He was respected for his confirmation instruction, his merry fellowship with old comrades in the British Legion and keeping wicket in a parents' match. When he died people marvelled at the number of flowers brought to the hospital and offers of blood for transfusion. He died on 9 July 1956 aged sixty-four years. (*M. Rock*)

The Revd Canon David J. Collyer with his wife Carol, and the Rt Revd Bishop Brown, September 1985. Following his education at Portsmouth Grammar School, Keble College, Oxford, and Wescott House Theological College, Cambridge, the Revd Collyer took up an Assistant Curate's post in North Birmingham in 1963. Since then he has held a variety of posts and voluntary offices within the City, whole-heartedly involving himself in the development of a radical and non-institutional style of youth work. He was Rector of St Laurence Church, Northfield, from 1973 to 1978 and was instrumental in raising sufficient funds to provide an Elderly Persons' Housing Development on Church Hill and to convert the large Rectory into a Pastoral Centre, which still provides a wide variety of uses and activities for the parish. The Revd Collyer, who was appointed Honorary Canon and Treasurer to Birmingham Cathedral in 1995, is currently Chief Executive of Lynton Marketing Limited, an independent faith-sponsored regeneration company, and continues to serve the Northfield area by voluntarily chairing several committees and trusts at the Royal Orthopaedic Hospital. (*Revd Canon D.J. Collyer*)

St Laurence School children say farewell to the Revd Tom Thompson, 20 July 1982. The Revd Thompson was Rector at St Laurence Church from 1978 to 1982 and his wife Mary was a teacher at St Laurence C/E Infant School. (*Birmingham Post & Mail*)

Barbara Davis (Headteacher) and Jean Smith (PTA Secretary) at Barbara's retirement in July 1981. Born in Pontypool, Barbara was educated at Pontypool County School for Girls. She trained at Birmingham Teachers' Training College, and the Young Women's Christian Association, following which she became Club Leader in York and Swansea. She was appointed Youth Club Organiser at Pontypool Education Settlement, and was seconded to Monmouthshire Education Committee to run youth clubs in the Eastern Valley. On returning to Birmingham she first taught at Highter's Heath School, and was then appointed Head of Infant Department at Pineapple Junior and Infant School, Kings Heath. For a short while she was appointed Deputy Head of St Laurence Junior and Infant School under the Revd Penny until the Junior Department moved to new premises on Bunbury Road. In 1962 she became the first Head of St Laurence Infant School, a post she held for almost twenty years. She remained at the original 1837 school with 392 pupils for the next ten years, moving to the new premises on the present site in 1972. (*J. Smith*)

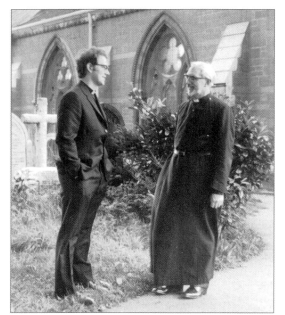

The Revd E.A. Penny with his son John outside Acocks Green Church on John's wedding day, 29 September 1969. In 1952 Mr Penny was appointed Head of St Laurence Infant and Junior Schools, later, when the schools were split, becoming head of the junior section with a corresponding reduction in salary! As the school was spread over three sites when he arrived, the Revd Penny was frequently seen cycling from one site to another. As a great lover of music and a talented musician he encouraged all its aspects among the pupils, and the school choir regularly competed in Northfield Music Festival. In the summer of 1953 he hired a train (and ten buses from London Transport) to take 750 parents and children from Northfield station to see the Coronation decorations in London. The Revd Penny retired in 1970 after seeing the first stage of the new school buildings come into operation. (*The Revd E. J. Penny*)

The Revd Penny (back row, centre) produced two operettas, *Purple Toadstools* for which he wrote the music, and *The Horn of Ozan* for which he wrote both words and music. First produced at his former school in London, *Purple Toadstools* was performed here in May 1954 in the Church Hall by the staff and pupils of St Laurence School. It was hailed with delight by large audiences, including a party from London. Portraying a moral thread of triumph of goodness over skulduggery, the fight between robbers in Wookey Wood was greeted with wild enthusiasm. It was reported in the press that the children had obviously benefited from careful musical training, with most effective incidental music being provided by recorders, piano and tympani, and a notable feature was that all the words came over clearly. (*J. Upton*)

22 YEARS RONALD STREET 35 INS. HIGH.
'THE CHEEKIE LITTLE CHAPPIE'
FRED ROPERS WONDER MIDGETS.

Ronald Street was a midget whose family ran Northfield Dairies and originally lived on a smallholding on the Duck's Elbow, before moving to a new house in West Heath Road. In the 1930s and '40s Ronnie travelled the world as an entertainer and member of Fred Roper's Wonder Midgets. In his prime he was 35 inches tall, though he finally reached 4ft 9in. Ronnie married another midget and they moved to Tampa, Florida, where they had five normal-sized children who still live there. In the mid-1960s his name appeared on a poster in Tampa as an entertainer with Ringling Circus. Born in about 1914, Ronnie died in the early 1980s. He attended St Laurence C/E School and was a friend of Jack Brown (from Brown's farm) who was very tall and well built. (*Above left: C. Read, above right: M.A. Street*)

Irene Such lived next door to the Streets and remembers a tailor using her as a model to fit a coat he was making for Ronnie. To this day she can remember the beautiful quality of the material. She believes this was for his act impersonating the entertainer and comedian Max Miller, who was very tall and always dressed in a camel coat and trilby hat for his acts. She also remembers her father, Police Constable Wiggins, who was over 6ft tall, and Ronnie posing together – with their respective large and small bicycles – for a photograph for a theatre agent. (*M.A. Street*)

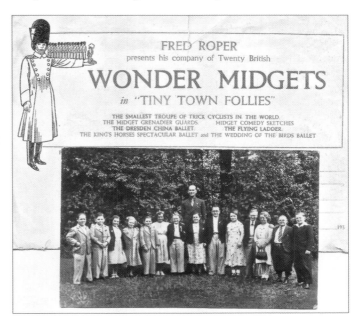

FRED ROPER
presents his company of Twenty British

WONDER MIDGETS
in "TINY TOWN FOLLIES"

THE SMALLEST TROUPE OF TRICK CYCLISTS IN THE WORLD.
THE MIDGET GRENADIER GUARDS. MIDGET COMEDY SKETCHES
THE DRESDEN CHINA BALLET. THE FLYING LADDER.
THE KING'S HORSES SPECTACULAR BALLET and THE WEDDING OF THE BIRDS BALLET

Seen here with his goat Jack Hunt, who lived in Cock Lane, always wished to be a vet, but unfortunately money was not available for his training. However, he developed a natural affinity towards animals and had a tabby cat called Dick who followed him everywhere, even travelling on the trams with him. Many people have recalled how he always wore a long white apron wherever he went. Christine Read (née Morris) recalls her mother, Muriel, visiting Jack and his family for tea during the depression of the 1920s when everything was very scarce. After eating tea Jack asked her if she had enjoyed the sandwiches. She replied that they were delicious – only to be told the filling was the goat. Jessie never really knew whether this was so, but swore the goat was never seen again after that! (*C. Read*)

Ken Harvey, who worked both for Roy's Bakery and Quinney's Dairy Farm, delivered milk around Northfield before joining the Lancashire Fusiliers, and is seen here in 1944. While working at Quinney's he met and married one of their milk ladies, Rosetta Ellis. Quinney's owned Frankley Lodge Farm and supplied milk for much of the Northfield area. (*C. Read*)

Right: Harry Stubbs CMD, President of the Longbridge Social Club from 1928 to 1970, Executive Member CIU Ltd, Vice-President West Midland CIU Ltd, being presented with a retirement gift by Toni, the youngest daughter of Ray Frayne who was then steward of the Longbridge Social Club. Harry started his club life in Darlaston in 1916. He was transferred to the Austin Motor Co. by the government, married the same year and came to live in Northfield. In 1976, through his club and union work, he was invited to a Queen's Garden Party at Buckingham Palace. Harry was held in such high regard that at his Testimonial Concert some of the finest artistes in clubland volunteered their services, with tributes being paid by representatives of all club sections and breweries who presented retirement gifts to him and his wife. After being sacked from the Austin works Harry started a coal merchant's business with one horse and cart, and later, as trade grew, acquiring several lorries, which were frequently seen delivering in the Northfield area. (*Longbridge Social Club*)

Left: George Hemus, local shoemaker and historian, born in 1864, spent his boyhood and early working life in the Toll House, which had been rented by his foster-father George Witherford, after it had been untenanted and virtually derelict for many years. It was in these premises that Mr Hemus began his fifty years working as a shoemaker. Local people recall George reminiscing about 'The good old days' when he had many times walked to Selly Oak for a bottle of medicine from the 'local' doctor who lived opposite to where Deep Pan Pizza Co. is now. For this long, lonely and frightening experience he received the princely sum of one halfpenny! (*Northfield Library*)

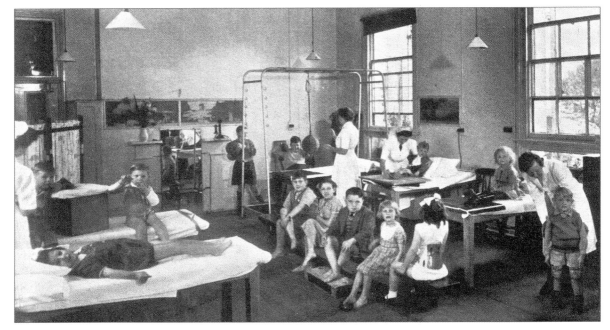

Children's Ward, Out-Patient Physiotherapy Department at the Woodlands Hospital. Physiotherapy Out-patient services, provided originally on a small scale in Daimler House, Paradise Street, were, in 1922, transferred to Islington Row and in 1927 to the hospital in Broad Street. An expansion of the out-patient work took place in 1926 and 1927 when, in co-operation with the various local authorities, clinics were opened at Dudley, Redditch, Stourbridge and Walsall enabling a number of patients to receive treatment near their homes. However, in 1929 a new Physiotherapy Department was opened at the Woodlands Hospital by Her Royal Highness the Duchess of York (the late Queen Mother). (*Woodlands Hospital School*)

Saturday night cinema at the Woodlands Hospital. In 1941 members of the Bournville Youth Club began sporadic film shows in the children's wards at the hospital (now the Royal Orthopaedic). At this time visitors were only allowed on Sunday and Wednesday afternoons and, as many of the patients remained in hospital for months or even years, the shows, which became very popular, were their major link with the outside world. A lot of hard work, planning and fund raising by both youth club members and hospital staff was needed, but as one surgeon said at the time: 'The provision of these weekly shows helps to cure the patients by keeping them cheerful. Operations alone are not enough.' (*Cadbury Trebor Bassett*)

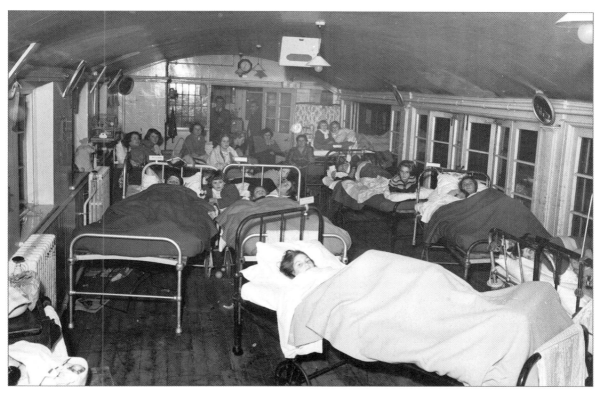

Beds rearranged on the Children's Ward in readiness for the show, *c.* 1942. Eric Neale recalls that there was always a buzz of expectation when 'the film men' entered the ward and their visit was regarded as the highlight of the week. The boys liked Westerns best, one particular favourite being *Destry Rides Again* with Marlene Dietrich and James Stewart. This really impressed them, but none were particularly fussy what was to be shown. By the 1960s the shows ended as TV sets were installed in the wards and daily evening visiting was introduced. (*E.J. Neale*)

Children of West Park Avenue presenting a television to Ward 11 of the Royal Orthopaedic Hospital. In 1979, The Year of the Child, the residents of West Park Avenue held a three-legged sponsored walk and a Bring and Buy Sale enabling them to raise sufficient money to present the Children's Ward with a brand new television. Many letters and cards of thanks and appreciation were later received from Sister Taylor and the children on the ward. (*J. White*)

In the centre, Louise Elizabeth Pickering, Alan's mother, pulling pints at the Great Stone Inn, early 1950s. Alan recalls the strong smell of beer each time his mother arrived home where she had splashed it down her white overall. He also recalls her emptying threepenny and sixpenny pieces out of her pockets, which were the tips she had been given by customers. It was his job to count the money before it was put safely away to go towards the cost of a retirement bungalow in Wales for his parents. They moved to Borth in 1972 and stayed there until about 1980. (*A. Pickering*)

This photograph was taken in 1937 from the gateway of 1 Dimsdale Grove looking across to Dimsdale Road in the background. The small boy Clive and the taller boy John (two of Alan Pickering's brothers) are returning from a visit to the horse-drawn Italian ice cream vendor who, for many years, travelled from his depot in Bristol Street to sell ice cream on the Allens Cross estate. The local children referred to the vendor as 'Antonio' and Alan recalls him calling out 'Icress' (which it was presumed was the nearest he could get to ice cream) as he toured the streets plying for trade. (*A. Pickering*)

Gordon Chatwin from Elmdale Crescent, who had a knee replacement operation on 15 March 1997 at the Royal Orthopaedic Hospital, participated in a sponsored walk on 1 June that same year to raise funds for the Wishbone Trust. The walk took place around Cannon Hill Park and Gordon raised £72.50. (*G.T. Chatwin*)

The certificate awarded to Gordon for completing his walk. (*G.T. Chatwin*)

During the Second World War children from Northfield C/E Junior and Infant School knitted garments to send to our troops. We see here a letter of thanks for his balaclava helmet from a grateful soldier sent to Mary (always known as Molly) Rock (née Sanders), who lived on the corner of Bell Hill and Fancott Road. (*M. Rock*)

Alan and Molly Rock were members of the St Laurence Youth Fellowship (see pages 70–1), a Guild for young people between the ages of fourteen and twenty-one. Its organisation required a great deal of foresight, as there was a need to cater for a wide variety of tastes and ideas. The Guild organised many different activities for the young people and membership rose rapidly. The aims of the Fellowship were 'To make progress in Intelligent Worship, and to do service for the Church of St Laurence; to make friends, and to enjoy the friendship and company of others; to undertake the care of a portion of the Churchyard'. (*M. Rock*)

Leaving Day at Tinker's Farm Senior Girls' School, 1944. Iris Harvey is fourth from the left, and the photograph also includes Iris Day, Mary Caswell and Eileen Cutler. (*I. Harvey*)

In 1954 one of the activities organised by Northfield Baptist Boys' Club for the National Boys' Club Week, which raised considerable public interest, was a 'Spot the Cuckoo' competition. Twenty-five shops on the Bristol Road participated and people were invited to search their windows for goods not usually sold there. The 'cuckoo' articles in the traders' 'nests' were very well hidden, and only one person, Mrs G.E. Handley of Trescott Road, found them all. Seen here among the prize-winners are, back row from left, first David Priestnall, third David Sorrill, fourth Yvonne Yearsley with Tony Judd last. Front row, third from left is Peter Sorrill. The Leader of Northfield Baptist Boys' Club, Dennis Pickering, is third from left on the middle row with the then minister of Northfield Baptist Church, the Revd K.N. Edwards, on his left. (*J. Sorrill*)

Natalie and Christopher Smith, with their cousin Stephanie Sorrill, admiring Christmas table decorations made by members of Northfield Baptist church. Proceeds from their sale, together with that raised by the church, supported the work of the Baptist Missionary Society in Bangladesh, where their uncle, David Sorrill, was serving. David, son of Bill and Joyce Sorrill, who grew up as a member of Northfield Baptist church, did overseas training at Selly Oak Colleges and left for East Pakistan in 1966 as a technical (builder) missionary. After the Pakistan civil war in 1971, when the country was renamed Bangladesh, he became an aid and development generalist involved in a variety of projects focused on poverty alleviation, retiring from overseas service in 1999. (*J. Sorrill*)

The wedding of Christine Morris to Kenneth George Read on 25 January 1951 at St Laurence Church. Despite being partially sighted Christine, from Hawkesley Mill Lane, was an ardent supporter of the Brownie and Guide movements in Northfield, and a very enthusiastic collector for charitable causes such as the Red Cross 'Penny a Week Fund' and Alexandra Rose Day. In 1945 she joined the ATS and was a member until 1947 when she became a part-time member of the 469 Heavy Ack-Ack Company of the Territorial Army at Brandwood as a Medical Orderly, where she stayed until her marriage. Ken, from Mavis Road, was studying to be an architect prior to being called-up into the Royal Engineers in 1945. Following National Service he worked as Administration Project Manager with Quickform. (*C. Read*)

The wedding of Irene Niblett to William Coombes-Lewis at St Bartholomew's Church, Easter Saturday 1943. Afterwards the guests assembled at the family home in Allens Farm Road for the wedding breakfast. William had been in Canada training to be a Radio Operator in the RAF. He concluded his training in London prior to a weekend leave for his marriage, and the lady he was billeted with made him a wedding cake. Unfortunately, he left the cake at the railway station on his way home! After the weekend he was posted to Singapore until the end of hostilities, returning to his job at Cadbury's as a Shop Floor Supervisor where he stayed until retirement. (*R. Ricketts*)

Mr Gulcher's class at St Laurence C/E Old School, 1940. Back row, left to right: Tony Morgan, Edward Sale, John Grant, Percy Brown, -?- , John Arnold, Pat Curtis, Alan Needle, Ronald Freckleton. Third row: Mr Sage, Reggie Ashworth, Kenneth Tithacote, -?- , John O'Dell, George Lee, Brian Furniss, Michael Davis, John Robinson, Anthony Green, Kenneth Ray, Gerry Morgan, Mr. Gulcher. Second row: Doreen Sullivan, Sheila Holder, Beryl Mason, -?- , Barbara Holtom, -?- , Gillian Fessey, Joan Baines, Pamela Chiswell, Denise Rose, Joyce Mander, Rachael Rowley. Front row: Helen Thomas, Dorothy Edwards, Betty Wood, Vera Scott, Heather Knight, Molly Sanders, ? Baines, Pat Walford, Alma Law, Jean Weston. (*A. Green*)

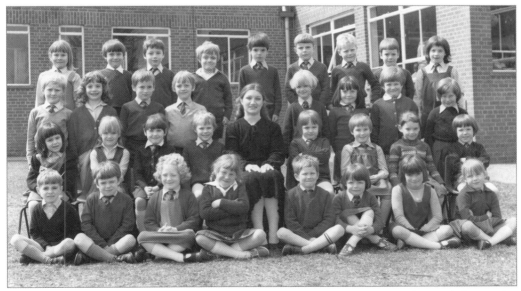

Miss Jane Smith's class at St Laurence C/E Infant School, June 1980. Back row, left to right: Louise Fletcher, Nigel Holtom, James ?, Paul ?, Jeremy Baker, Andrew Smith, -?-, Simon Booth, Rachael Kershaw. Third row: Royston Woodcock, Vicki Mott, Laurence Harding, James Clay, ? Hook, -?-, -?-, Vanessa Allsebrook. Second row: Anna Schwarz, Rebecca Aston, -?-, Simon Conlon, Simon Kenny, -?-, Nicola Baker, -?-. Front row: Mark Boulcott, Paul Keenan, -?-, Hayley Britton, Nicholas Michael, -?-, -?-, -?-. (*J. Smith*)

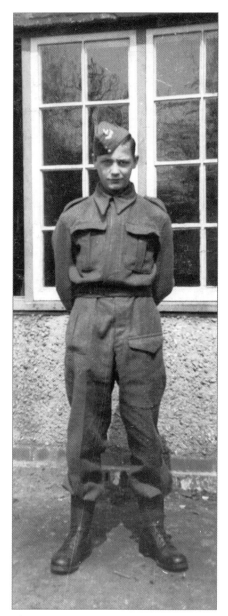

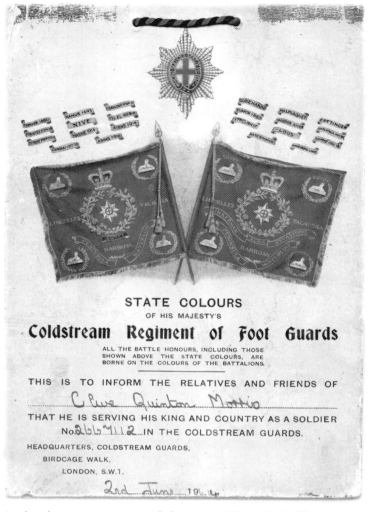

STATE COLOURS
OF HIS MAJESTY'S
Coldstream Regiment of Foot Guards

ALL THE BATTLE HONOURS, INCLUDING THOSE
SHOWN ABOVE THE STATE COLOURS, ARE
BORNE ON THE COLOURS OF THE BATTALIONS.

THIS IS TO INFORM THE RELATIVES AND FRIENDS OF

Clive Quinton Morris

THAT HE IS SERVING HIS KING AND COUNTRY AS A SOLDIER
No. 2667112 IN THE COLDSTREAM GUARDS.

HEADQUARTERS, COLDSTREAM GUARDS,
 BIRDCAGE WALK,
 LONDON, S.W.1.

2nd June 196.4

Clive Quinton Morris, aged fourteen, in Home Guard uniform outside his home in Hawkesley Mill Lane, 1941. Clive, a member of the last Morris family who worked Digbeth Mill, (see *Northfield Past & Present*) attended Tinker's Farm School. He enjoyed being a member of the Home Guard so much that when he became of age he joined the regular army. (*C. Read*)

As the above acceptance card shows, on 2 June 1944 Clive was accepted into the Regiment of the Coldstream Guards, signing on for a period of nine years. He became a member of the 1st Guards 16th Independent Pathfinders and served in Cyprus, Egypt and Germany. After leaving the army in 1953 he became manager of the Oak and the Bristol cinemas. Just recently Christine, Clive's sister, met a lady who had worked for him and recalled what a stickler for discipline he was. Every day he used to line up all his employees for inspection before they began work to make sure they were clean, tidy and had freshly polished shoes. (*C. Read*)

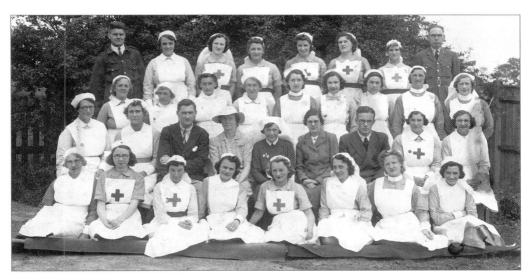

Northfield Mobile Units 38 and 39, on a piece of ground at the front of Northfield swimming baths where, during the Second World War, the Northfield Mobile Units were based, 1941. They were units of doctors and nurses who, after air raids, travelled to the blitzed areas to give medical help to the injured. Back row, left to right: Mr J. Wallen, Nurses S. Hunt, B. Thomas, A. Woodgate, I Fryer, I. Bailey, E. Whitehouse, Pilot Officer H.R. Hall. Third row: Nurses M. Townsend, L. Atkin, E. Atkin, E. Southwell, K. Peplow, R. Millinchip, M. Hemming, V. Wood, D. Evans. Second row: Staff Nurses A. Woodcock, C. Taft, Drs W. Morrison, E. Gittins, Sister M. Royston, Drs B. Thomson, A. Scott, Staff Nurse E. Charlton, Nurse R. Gilkes. Front row: Nurses K. Pexton, M. Yorke, A. Langston, R. Jarvis, B. Hirons, J. Stringer, M. Thomas, W. Lucas. (*I. Rea*)

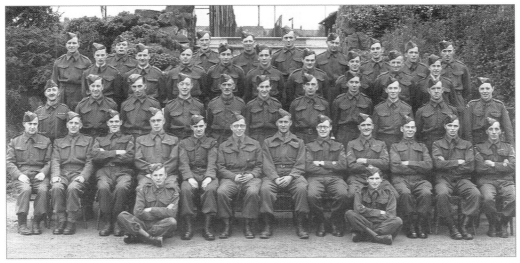

The Kalamazoo Home Guard, 1944. John Welch's father, Jack Welch, is third from the right on the second row from the front. The Company Commander was T.B. Morland MD. Two members of the group were veterans of the Battle of the Somme in the First World War. Shortly after the photograph of the Northfield Mobile Units (above) was taken outside the swimming baths a hut was erected on the piece of ground for use by the Northfield Home Guard. (*J. Welch*)

Ken Mason and Cyril Dawson, members of the Kalamazoo Fire Brigade on 'wet drill'. During the war Ken, a conscientious objector, joined the Kalamazoo Fire Service as a volunteer and remembers being reprimanded on the one fire he attended for doing more damage with the water to douse the fire than the fire itself would have done! (*K. Mason*)

Sunday morning practices often included light pump and ladder drill. Seen here are Ted Blackstaffe, Les Jones, Harry Cutler and Ken Mason on the pump and Arthur Ellis, Trevor Doughty, Cyril Dawson and Frank Coe with the ladder. The Chief Officer, Fred Lea, is standing by. In 1941 Ken Mason began work, on a temporary basis, in the Cost Office at Kalamazoo where he stayed for forty years, retiring in 1981. When presented with a gold watch after twenty-five years service it was noted that 'So far he had managed to ensure that Kalamazoo prices were higher than their costs on most items'. (*K. Mason*)

Harry Taylor, c. 1914. On leaving school Harry, who lived in Selly Oak, joined Northfield Fire Brigade, but around the turn of the year he disappeared. Early in 1916 a policeman knocked the door of his home to tell his family he was due to be shot the following morning for desertion from the army. His father explained he could not be shot for desertion, as he was only fifteen, and officially was not old enough to be in the army. His father cycled to Norton Barracks at Worcester with his birth certificate and after much argument Harry was released. It later transpired he had walked from Selly Oak to Worcester to join the army, had fought in Gallipoli and was one of the few to return. (C. Read)

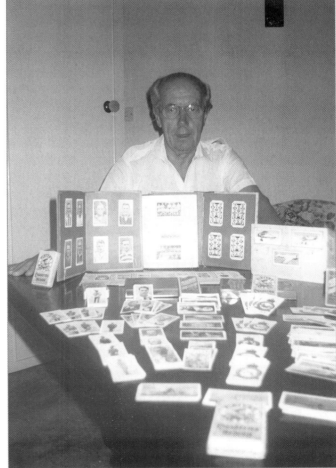

A short while later, following a spell working with his father at the Ariel Motor Cycle works, Harry disappeared again and was not seen until 1920 when he arrived back home in the uniform of a Sergeant Major in the Royal Marines, with a wife and son. He had walked and hitched his way to Portsmouth to join the Marines and spent the rest of the war in the trenches, apparently escaping injury. It appeared he led a charmed life. In the Second World War Harry became an MOD Inspector for the manufacture of armaments, travelling the country night and day, often during heavy raids, but miraculously again escaping injury. He was a heavy smoker and the photograph shows David Taylor, his nephew, with a collection of cigarette cards and packets left to him by his uncle. (J. Smith)

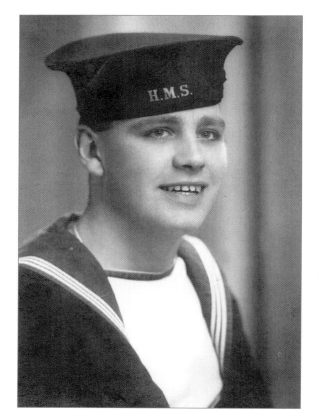

Albert Holley, born in 1921, resided in Inverness Road for many years. At the outbreak of the Second World War he joined the Navy and while serving as an Able Seaman in 1941–2 came home on leave, on a weekend pass. He and his friend Albert White arrived in Birmingham in the middle of a big air raid. They boarded a tram to Northfield, which, because of bombs dropping all around, only reached the cinema in Selly Oak before everyone was ordered off to shelter. However, the two Alberts decided they wanted to get home, and defying the raid, proceeded to drive the tram to the Black Horse, where they left it and walked up Frankley Beeches Road to their homes. (*H. Holley*)

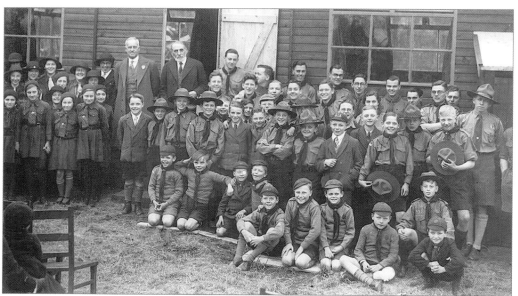

A group of Northfield Cubs, Scouts, Brownies and Girl Guides, *c.* 1935. Hazel's late husband, Raymond Holley, is among the Scouts and his younger brother, Harold, is a Cub kneeling on the left of the front row. (*H. Holley*)

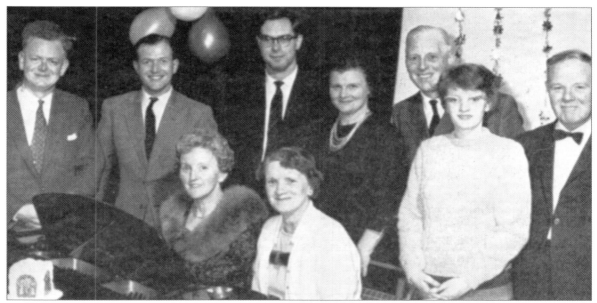

Bournville Music Club Christmas Party, December 1963. Back row, left to right: H. Tanner, R.S. Blaine, J.D. Smith (co-author), A. Powell, L. Cull, J. Smith (née Whitehead), H. Stringer. At the piano: N. Cull, C. Whitehead. Nancy (Contralto) and Leslie Cull (Baritone), from Quarry Lane, were both well-known vocalists and singing teachers. Nancy was a member of the BBC Singers and during the 1950s she acted as Chorus Mistress to Northfield C/E Parent-Teacher Association's musical productions in the Church Hall. Leslie studied at the Midland Institute under Sir Granville Bantock. His variety career began at the Court Restaurant, Corporation Street, and he later became an authority on Birmingham music halls. Together with his partner, Harry Stringer (nicknamed Curly because of his straight hair), the duo was known as Clifton and Glenville. A warm, friendly and gentle man, Leslie was also Musical Director of many local choirs, and had been conducting Selly Oak Townswomen's Guild choir only hours prior to his death in 1982. (*Cadbury Trebor Bassett*)

Edward J. Mason, the well-known writer for radio and television, seen during his visit to Bournville on 19 December 1959 when he was the guest speaker at the Directors' and Staff Luncheon. Ted Mason, who for several years lived in Pamela Road, was born in 1912 and began writing radio scripts in the late 1930s. He was best known as one of the creators of *Dick Barton, Special Agent*, and of Britain's most famous farming family, *The Archers*, whose fortunes and misfortunes are still followed by many listeners today. Ted began work at Cadbury Bros Ltd in 1928 but left in 1946 to take on the *Dick Barton* assignment and become a full-time professional scriptwriter. Once someone wrote to tell him that he had got the Archer family all wrong and he ought to listen to a certain other feature if he wanted to learn to do his job properly. He didn't worry – he was also the author of the other feature! (*Cadbury Trebor Bassett*)

Adam Harris and Nilesh Rae playing in the garden of Catherine House Day Nursery, Woodland Road, *c.* 2001. Catherine House Day Nursery Schools provide accommodation for children ranging in age from three months to five years. As well as a secluded rear garden containing play equipment, each nursery has playrooms providing a comprehensive and varied range of stimulating materials, educational toys, and pre-school activities. Their aim is to provide facilities for the development of basic pre-school reading, writing and number work skills and concepts. A qualified teacher is employed for the three-and-a-half to five-year-old groups. (*Catherine House Day Nursery*)

Children at Mickleton Day Nursery in Norman Road, 1999. Begun by Mr and Mrs Purser with five children in 1967, Mickleton Nursery still thrives today as a family business and is now run by Phil and Lesley Watson. It has always been renowned for its happy and homely atmosphere. When it first began the morning session ran from 9 a.m. to 12 noon at a cost of 4s 6d, the nursery closed from 12 noon – 1.30 p.m. for lunch and the afternoon session cost 4s. Mrs Purser retired in 1980 when Mr and Mrs Jones took over; they retired in 2000. (*Mickleton Nursery*)

Staff of Trescott Road Infant School, June 1952. Left to right: Audrey Whitehouse, Joan Pegler, Lena Kessler, Sheila Fenton, Molly Sanders, Pat Brown, Joyce Holland, Ann Chilton, Mary Burnell. (*M. Rock*)

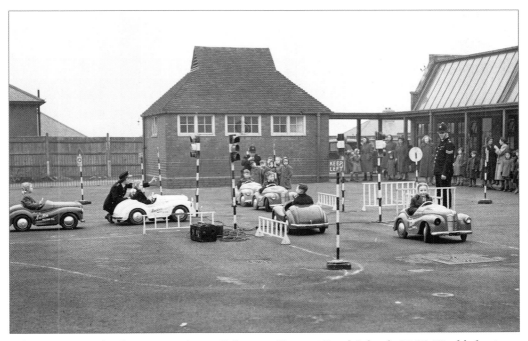

Police giving road safety instruction to Infants at Trescott Road School, 1955. Disabled miners made Austin pedal cars at Bargoed in Wales during the Second World War. In the Fiftieth Anniversary celebrations of the Austin Motor Co. children competed in races in Austin pedal cars with a commentary provided by Kenneth Horne of radio fame. (*M. Rock*)

The Girls' Brigade Division Display in the Central Hall, Corporation Street, Birmingham, 1981. At this display the girl in the wheelchair was presented with a mobility gift. (*G. Harper*)

At the same display the 35th Northfield Baptist Church Company, together with dancers representing many Birmingham companies, performed *Make me a Channel of your Peace* to music. The dance was performed at many different venues including the Royal Albert Hall. Sadly, because of the rising costs of hiring a venue, the event has now ceased. (*M. Harper*)

Northfield post office, 1980s. Following its beginnings in a room of Northfield Institute, the post office moved to a long, low, one-storey building erected in 1906 with a gabled porch and facing the east side of the Institute. Attached was the postmaster's house which today still stands high above the road fronted by a brick wall. With the widening of the road, the banks before the post office were removed, leaving the building on its present terrace. The post office stayed there until 1937 when the GPO built the neo-Georgian building on the Bristol Road, which has since had a one-storey extension built out in front of it. (*A. Evans*)

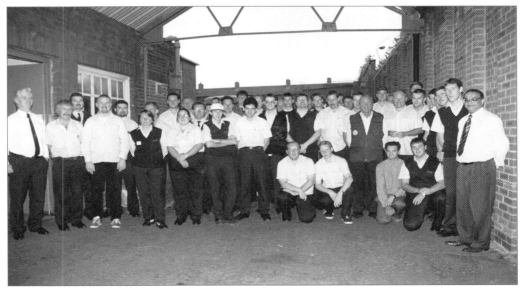

A group of postal workers, including the authors' cousin, Nick Whitehead, outside Northfield post office, *c.* 1990. (*N. Whitehead*)

Medication prescribed many years ago for Mrs P. Carter. Mrs Dorothy Hargest presumes her mother never had it made up as many people were very poor in those days and she may not have been able to afford the cost. Sadly her mother passed away shortly after her 94th birthday in October 2002. However, the lack of medication in 1934 did nothing to shorten her life! (*D. Hargest*)

Mrs P.N. Carter for whom the medication was prescribed. (*D. Hargest*)

The prescription was tidily put into an envelope, which gave details of the dispensing chemist. (*D. Hargest*)

Councillor Marjorie Brown, Birmingham's Lord Mayor from May 1973 to May 1974, presenting a Certificate of Appreciation from the Royal British Legion Poppy Appeal to Ellen Collins, at the Northfield branch of the Royal British Legion in Quarry Lane. The certificate reads, 'We gladly award this Certificate to Mrs Ellen Collins in grateful recognition of the splendid voluntary effort on behalf of the Poppy Appeal. Upon such services fully and freely given, the success of our yearly appeal depends.' Ellen, a poppy seller for forty years, was top seller of the year in Birmingham, raising over £100. (*E. Collins*)

Jayne Brunt (née Williams), back row, left, was a Maid of Honour to the Northfield Carnival Queen in about 1974. (*Northfield Messenger*)

Victoria Lees's eighth birthday party at McDonalds in Bristol Road South, 1984. Parents of younger children warmly welcomed this exciting new venue for organised parties as it saved them a lot of work and mess. (*B. Lees*)

Victoria Lees and Rebecca and Thomas Foulger playing in the Boat in the former play area in Victoria Common, February 1979. In *Northfield Past & Present* we pictured the new play area which replaced the one shown here and, according to recent information from our local councillors, £500,000 is now to be invested into improving the overall state of the Common, and a new secondary play area, including play equipment and perimeter fencing, is part of the scheme. (*B. Lees*)

The opening of Laurence Court in 1983 by the Duchess of Kent, who is accompanied by Phillip Henslowe and Mrs Veronica Wootten. The Court, named after Mrs Wootten's father, Laurence Cadbury, who lived nearby at The Davids, is a group of twenty-two retirement flats for the elderly. It is built at the front of the present Priory whose order of nuns, the Sisters of Charity, act as wardens in an emergency. The land was originally occupied by the old Priory and its front gardens, and several magnificent, mature trees remain, all of which were incorporated into the landscaping. The layout is based around a central court, the focal point being a tiled-roof pergola, with seating underneath, surrounded by ornamental borders containing a variety of flowering plants and shrubs. There are other smaller flowerbeds outside the flats, which give the effect of a 'front garden' for each one. All entrances face inwards, giving a sense of tranquillity, security and a small private community. The buildings were designed to give the visual impression of a number of small, cottage-like dwellings linked together with balconies on both sides. (*D. Smith*)

A reunion of physiotherapists on the front lawn of Belmont, Hole Lane, early 1950s. In 1881 Belmont was home to Thomas and Mary Bayliss, their seven children and five servants, but in 1929 the house was rented by the Woodlands Hospital from the Bournville Village Trust to provide classrooms and accommodation for resident students. Pam Evans was a student at the Physiotherapy School there from 1946 to 1949 where the ground-floor rooms, plus an extensive gym built in the grounds, were used as lecture rooms. Internal students (those who had completed the orthopaedic nurses' training before doing the physiotherapy course) slept in bedrooms either in Belmont or at the Manor. Pam, as an external student (only doing the physiotherapy course), lived at home. (*P. Evans*)

Northfield Baptist Church Bank Holiday Ramble, Whitsun 1955. Rambles were a highlight of the church's life. The minister, the Revd Ken Edwards, is seen on the front row wearing 'that coat' with Barbara, his wife, to his right. Following a very successful ministry at Northfield he was called to Rhyl Baptist Church in North Wales, where he later retired due to ill health. David Shaw, extreme right of second row from front, became a director of the *Birmingham Evening Post & Mail*. Martin and Alice Powell, fourth and fifth from left on back row, were very prominent in the church; their daughters, Jackie and Wendy, are also in the photograph. Stan Lane, fourth from right on the back row, became a teacher and Baptist minister. (*B. Edwards*)

Northfield Baptist Church members processing from the hall in Woodlands Park Road, where the church originally met, along Bristol Road South to the present building for celebrations on the seventy-fifth birthday of the church in 1987. (*G. Harper*)

5

Celebrations

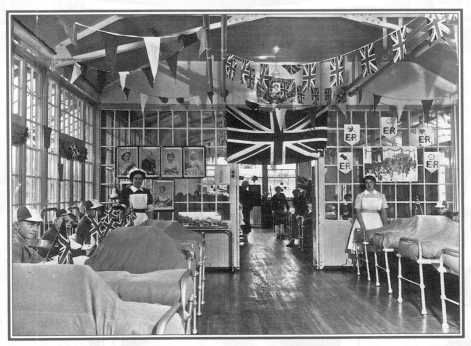

Ward 3, the Royal Orthopaedic Hospital, decorated for the Coronation celebrations on 2 June 1953. (*Woodlands Hospital School*)

A group of residents from West Park Avenue preparing to celebrate the Coronation of Queen Elizabeth II in June 1953. (*J. White*)

For many years the residents of West Park Avenue, seen here enjoying their celebration tea for the Coronation of Queen Elizabeth II in June 1953, have organised their own frequent and varied social activities. (*J. White*)

The Coronation of Queen
Elizabeth II, June 1953.
Mrs Chatwin, with son
David in her arms, is
watching over the
Coronation party tea in
Honiton Crescent.
(*G.T. Chatwin*)

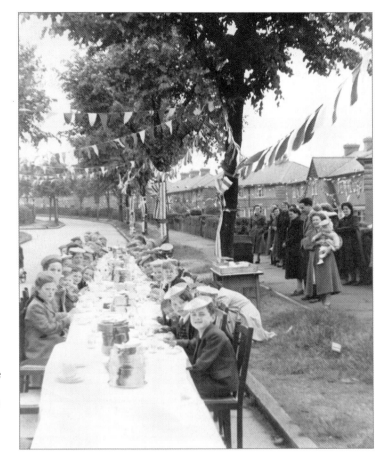

Molly Sanders's class at
Trescott Road Infants
School having performed
a maypole dance as part
of the celebrations for the
Coronation of Queen
Elizabeth II. The maypole
was given to the school
as a Coronation present.
(*M. Rock*)

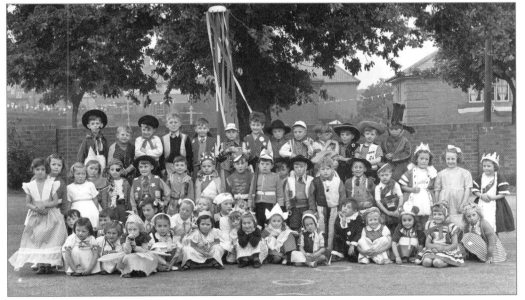

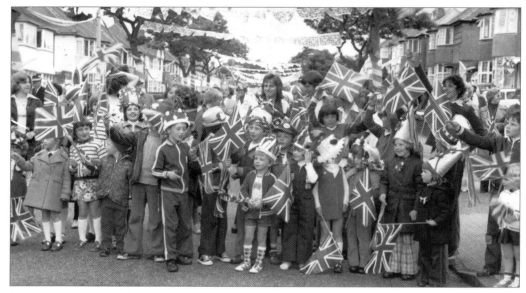

Everyone in West Park Avenue, from the youngest to the eldest, joined forces to celebrate the Silver Jubilee of Queen Elizabeth II in June 1977. Early in the year fund-raising began in earnest, and in addition to weekly house-to-house collections, monthly raffles were organised with prizes donated by residents. A bring-and-buy sale boosted the funds greatly, and the children helped by competing in a sponsored walk. (*J. White*)

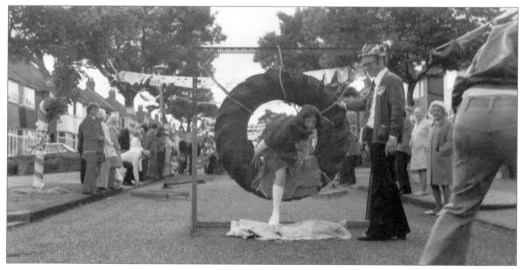

Arrangements were made for the road to be closed, plus food, games, prizes, races and a disco for the evening. In the middle of the road scaffolding was erected and covered, to enable eats to be in the dry if the weather was inclement. The obstacle course proved to be great fun. Mr Marsten made and decorated a jubilee cake in red, white and blue, and all the children, dressed in their fancy hats, enjoyed a wonderful tea. Following this they were all given a souvenir and Mrs Tieger, the eldest and longest living resident in the Avenue, distributed prizes. The Chief Fireman from the local Fire Station judged the best decorated house in the Avenue. (*J. White*)

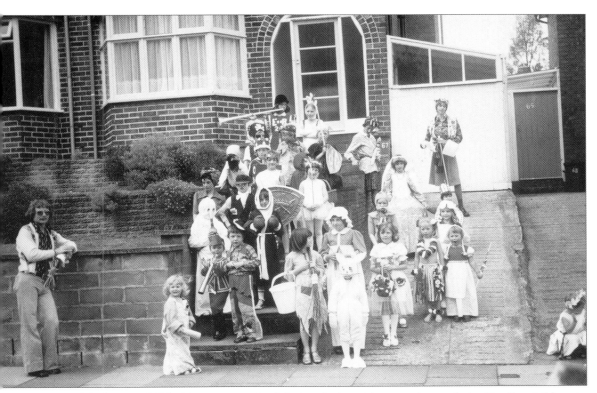

To everyone's delight a BBC Television crew arrived, but unfortunately came too early to film the children in fancy dress. Hats were hurriedly donned and each child given a flag before being rushed out into the road to be filmed. The Methodist minister and his wife judged the fancy dress and the bonny baby competition. Following the children's tea the adults enjoyed a buffet supper of either turkey or ham salad, finishing with a disco in the middle of the road, which continued until midnight. All the residents enjoyed themselves immensely and the children had a day they will always remember thanks to everyone's help and hard work. (*J. White*)

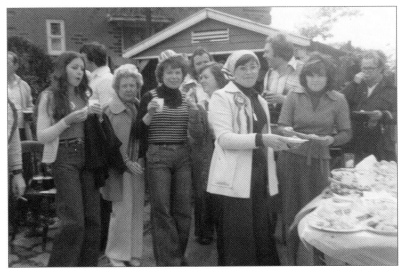

Seen here among residents enjoying their Silver Jubilee tea in Elmdale Crescent are Thelma Chatwin, Margaret Hill, Anne Chase and Gordon Chatwin. (*G.T. Chatwin*)

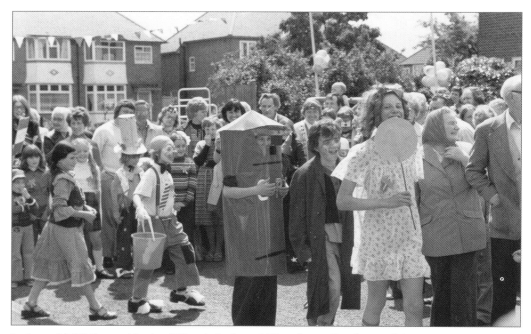

In June 1977 the residents of Hazel Croft and Kingshurst Road joined forces to celebrate the Queen's Silver Jubilee. The street was decked with bunting and a fancy dress parade was organised. (*J.M. Roberts*)

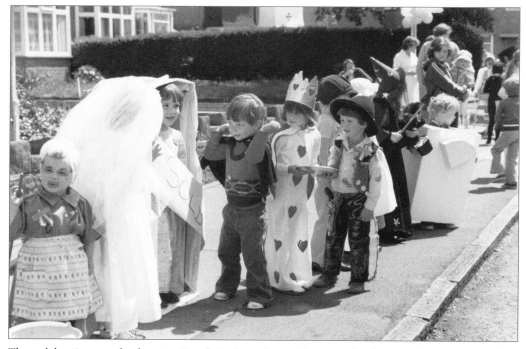

The celebrations took place in Hazel Croft, and seen here as the Queen of Hearts is Andrea Lane. (*J.M. Roberts*)

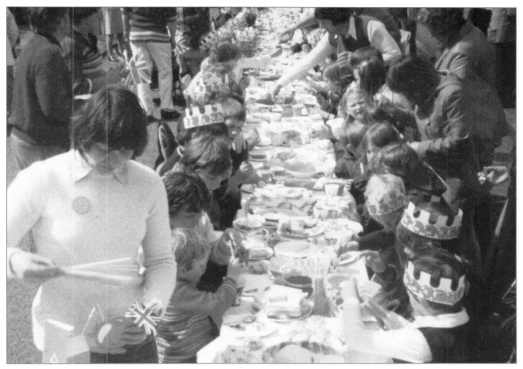

After the parade trestle tables were laid and all enjoyed a scrumptious tea. (*J. Lane*)

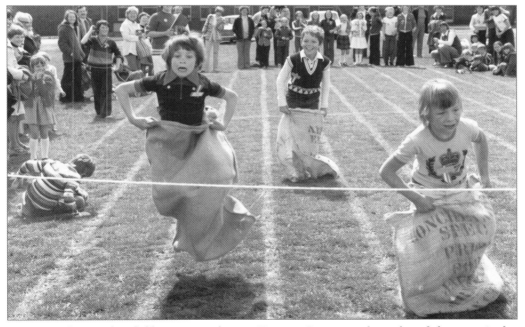

Following the tea the children were taken to Victoria Common where the adults organised a variety of races for their amusement. It had been a wonderful day and everyone retired home tired but happy. (*J.M. Roberts*)

Children at Ley Hill enjoying a tea party to celebrate the Queen's Silver Jubilee. Note the blocks of flats in the background, which have now been demolished along with most of the houses on the estate. (*E. Collins*)

Mr and Mrs Jones's Silver Wedding Party in the Church Hall at Frankley Beeches, 1946. (*J. Welch*)

A group of carol singers from
Bournville Girls' Athletic Club, cloaked
and hooded and carrying lanterns
singing at The Davids, the home of
Mr and Mrs Laurence Cadbury in Hole
Lane, Christmas 1956. This was an
annual event and the money collected
was always used for charitable
purposes. Laurence Cadbury shot the
bear in Alaska in 1913. (*Cadbury
Trebor Bassett*)

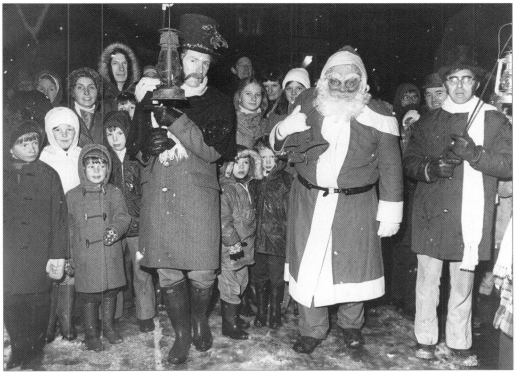

Santa Claus (Mick Poole), lamp men Colin Turner and Tony Hughes, together with carol
singers in West Park Avenue, 1978. Following months of fundraising, neighbours joined
together to build a colourful Santa's Grotto on the lawn in one of the front gardens where fifty
children each received a present from Father Christmas. The Christmas programme of events
began in the afternoon and at 7 p.m. Father Christmas, flanked by two men dressed in period
costume and carrying lanterns, and accompanied by the carol singing community together
with an accordion player, knocked on the doors of all the Avenue's forty-three pensioners. They
were greeted with carols and treated to small bottles of whisky. By 8.15 p.m. all had been
visited and the party returned home wet but with their spirit far from dampened. (*J. White*)

'Festival 900'. Mentioned in Domesday Book, St Laurence Church is probably the oldest church building in the Diocese of Birmingham. In 1986 the congregation planned a year-long 'Celebration of praise, faith and thanksgiving for the 900th Anniversary'. Mavis Toy and Sue Evans are on Reception at the Arts, Crafts and Flower Festival, which took place in June and was designed to show everything from Northfield's past as a nail-making village to the age-old craft of spinning. (*G. Salkeld*)

Birmingham Fellowship stall at the Festival Craft Fair. Throughout the year ladies of the 'Festival 900' Flower Guild created flower displays in the church echoing the theme of more than 900 years of Christian worship. For the eleventh century a facsimile of the Domesday Book was surrounded by wild flowers. (*G. Salkeld*)

Susan Teckoe, Stan ?, Irene Turner and her son at the Homemade Produce stall. The flower display for the twelfth century concentrated on the Crusades. One on monastic life followed, then the Black Death represented the fourteenth century. They were followed by arrangements representing the Wars of the Roses, the Reformation, the Great Fire of London, the Industrial Revolution, the Victorian Age and finally Wars and Space. (*G. Salkeld*)

Gill Hands, churchwarden and chairman of the 'Festival 900' committee, at the Souvenir stall. Hundreds of people took part in the celebrations, helping in every way possible from lending old photographs of the area to helping organise a pilgrimage to Lindisfarne. The pilgrimage, one of the highlights of the Festival, began on 30 April when three members of the St Laurence congregation began the long walk from Lindisfarne taking the route of the old pilgrims. They planned to arrive in Northfield on Sunday 18 May. (*G. Salkeld*)

A hot air balloon giving rides to visitors at Northfield Carnival in 1988. (*E.J. Neale*)

Turves Green Boys' School Steel Band performing at Northfield Carnival, 1988. Among a long list of attractions at the annual Carnivals were dozens of marching bands, jazz bands from the Black Country, dance troupes and a display of veteran cars by the Patrick Motors Group. (*E.J. Neale*)

After a gap of nine years Northfield Carnival was revived in 1987 and began with a procession of twenty colourful floats from Mill Lane to the carnival ground on Victoria Common. Seen here are Brownies from the 3rd Birmingham Pack, dressed up and in carnival spirit joining in the procession that year. Ann Evans can be seen at the back on the right with her daughter on the extreme left. (*Birmingham Post & Mail*)

The Carnival Princess leading the parade in a decorated pony and trap at Northfield Carnival, 1988. (*E.J. Neale*)

Celebrations in Honiton Close for the wedding of Prince Charles and Lady Diana Spencer on 29 July 1981. (*E. Collins*)

A joint party for members of Northfield Baptist Church and residents held outside Ash Grove, to celebrate the Queen's Golden Jubilee and the ninetieth birthday of Northfield Baptist Church, June 2002. Following the completion of the new church buildings in 1972, the Deacons and church meetings examined a number of schemes aimed at increasing the Church's impact on the community at Northfield, providing better community service and increasing the spiritual life of the church. The most fruitful of these ideas proved to be the scheme for building sheltered and warden-controlled accommodation adjacent to the church. From a suggestion and dream in 1982, Ash Grove became a reality by the mid-1980s, thus adding a tangible dimension to the church's presence in the centre of Northfield. (*G. Harper*)